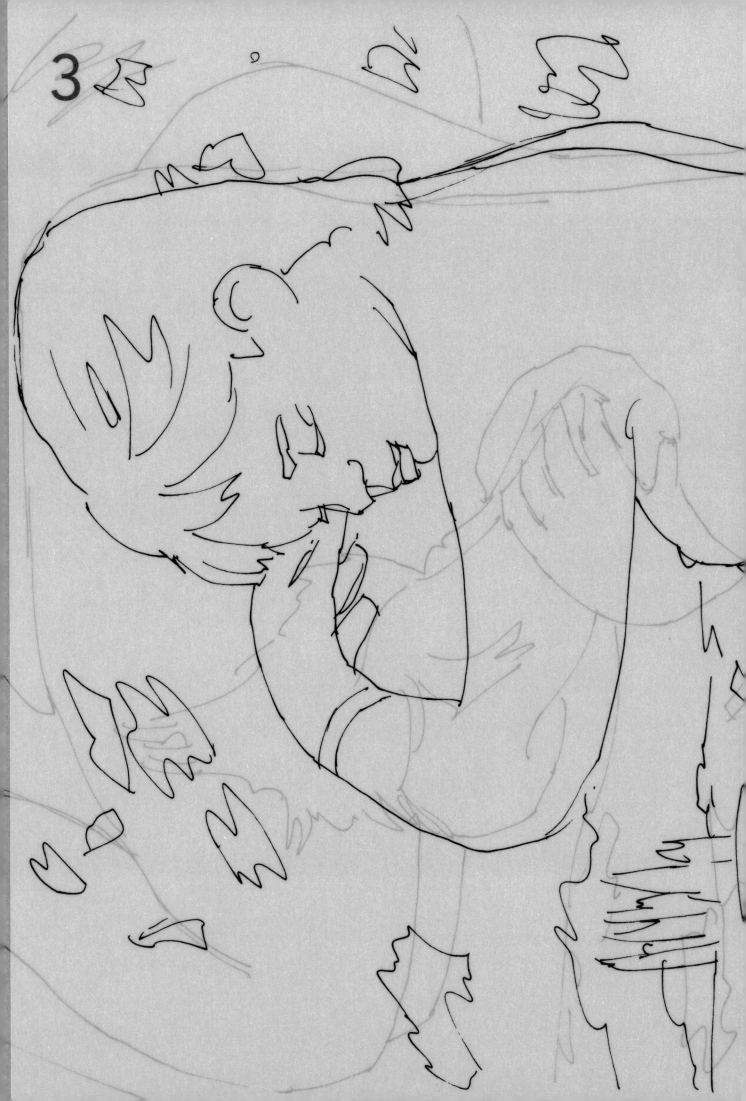

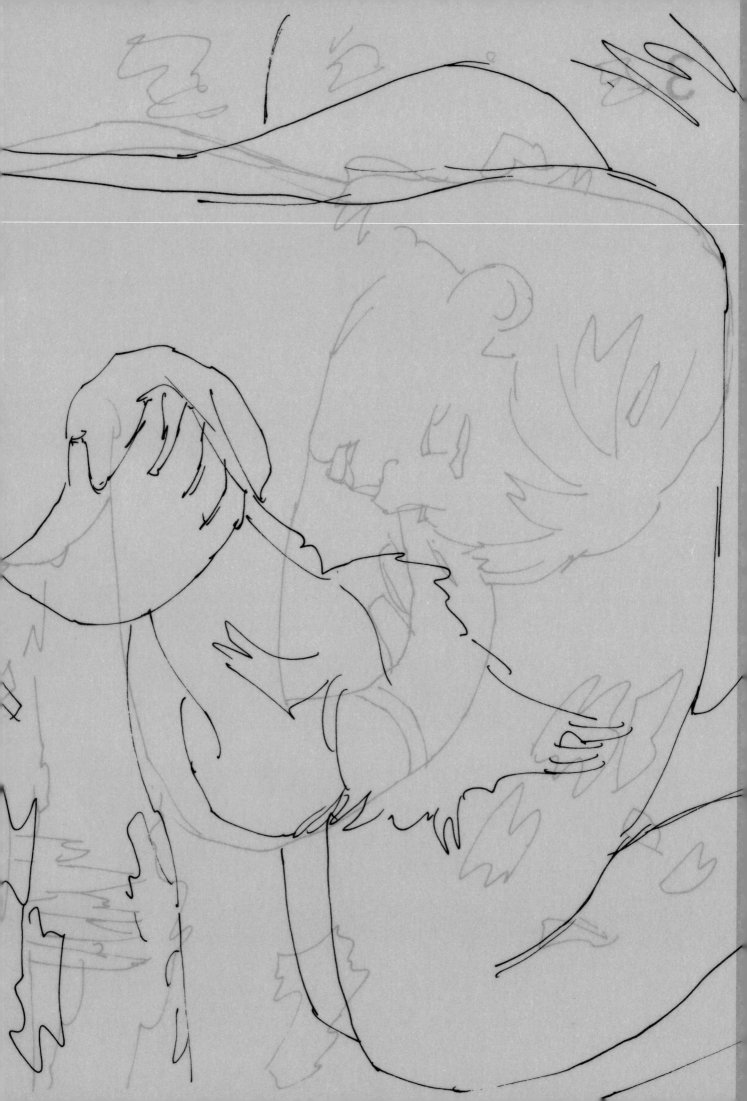

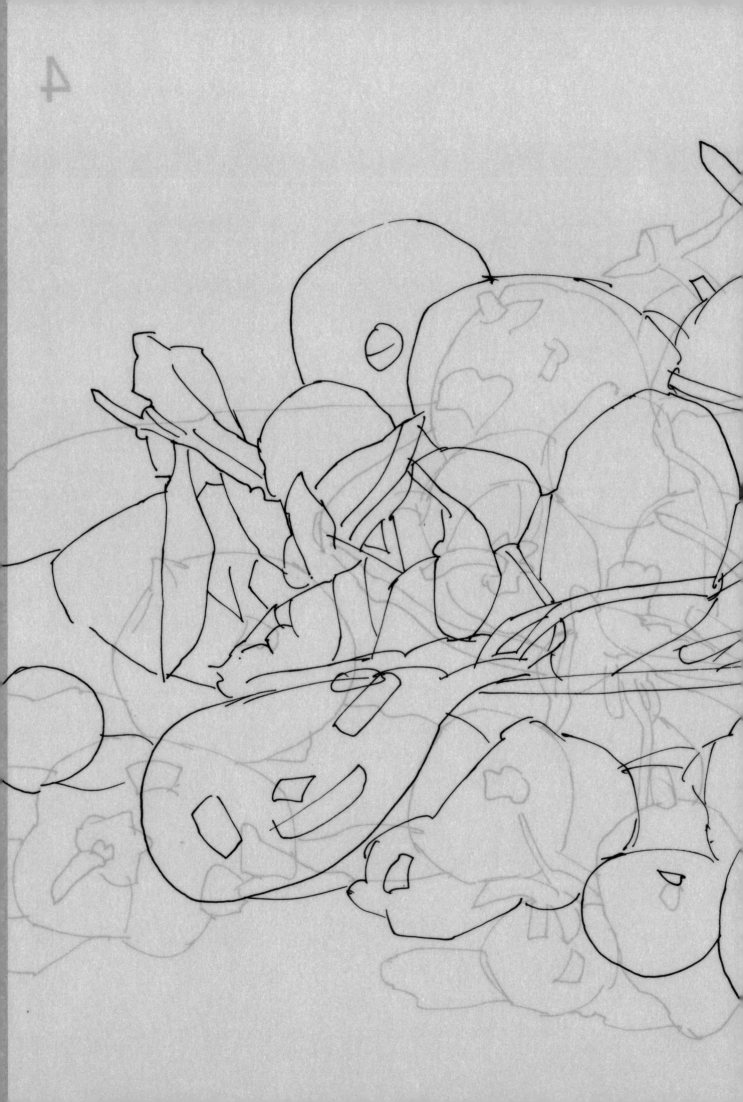

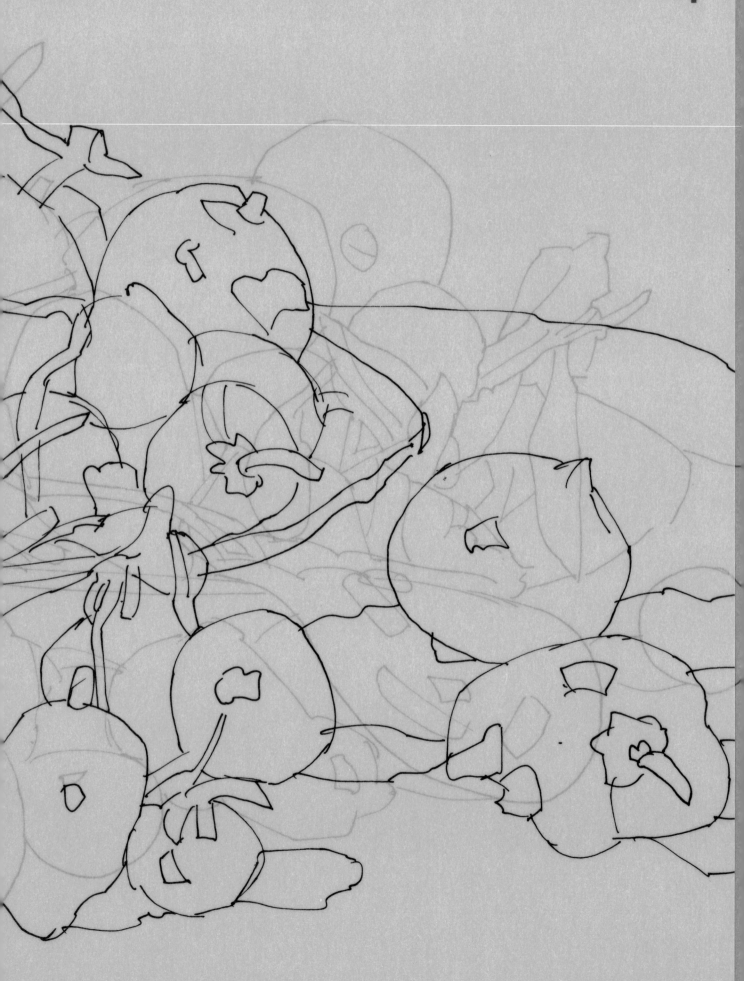

5

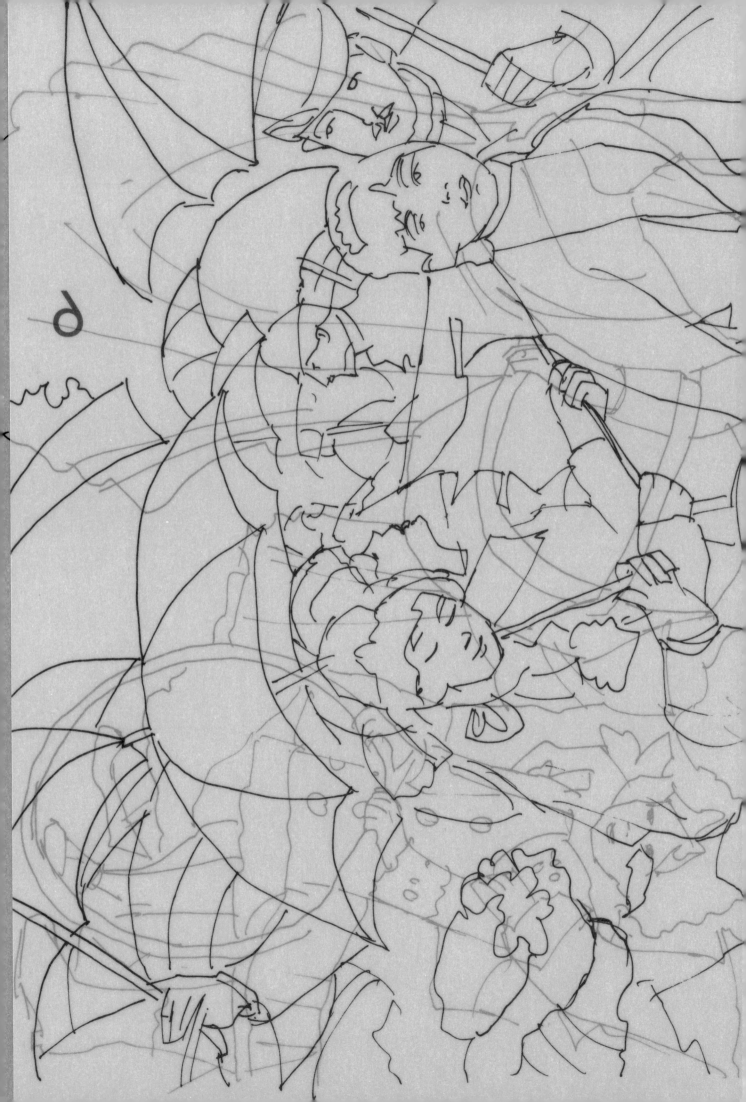

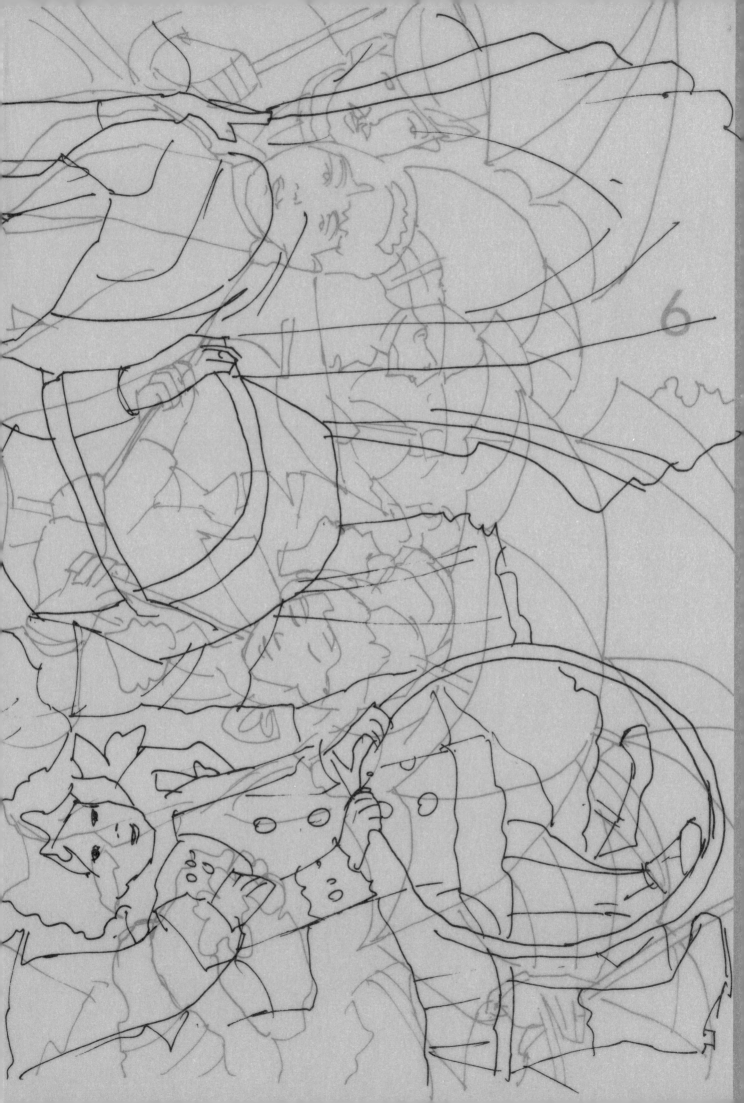

Renoir

Noel Gregory

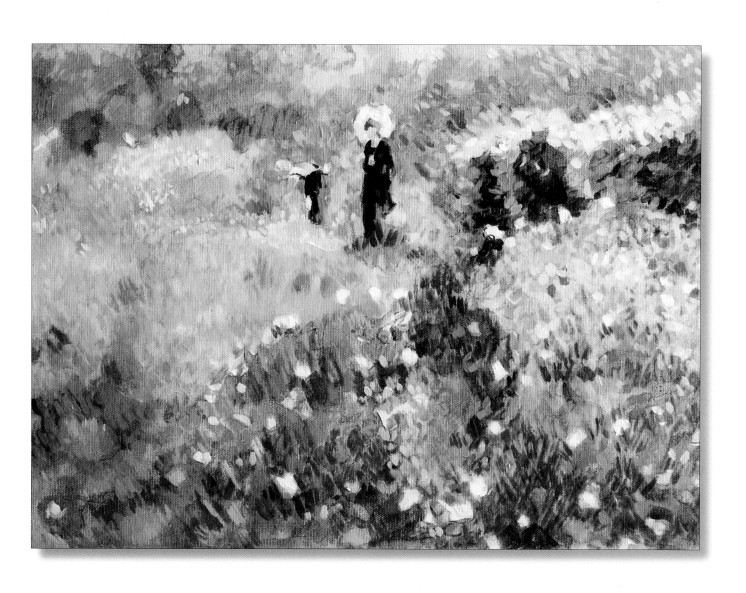

SEARCH PRESS

First published in Great Britain 2011

Search Press Limited
Wellwood, North Farm Road,
Tunbridge Wells, Kent TN2 3DR

Text copyright © Noel Gregory 2011

Photographs by Debbie Patterson at Search Press Studios, except
for pages 1, 2, 4–5 and 64, artist's own; page 7 © The Art Archive,
Collection of Annette Vaillant/Marc Charmet; and pages 20–21, 50–51
and 62–63, Paul Bricknell at Search Press Studios.

Photographs and design copyright © Search Press Ltd 2011

ISBN: 978-1-84448-578-9

The Publishers and author can accept no responsibility for any
consequences arising from the information, advice or instructions given
in this publication.

Readers are permitted to reproduce any of the tracings or paintings
in this book for their personal use, or for the purposes of selling
for charity, free of charge and without the prior permission of the
Publishers. Any use of the tracings or paintings for commercial
purposes is not permitted without the prior permission of
the Publishers.

Suppliers
If you have any difficulty obtaining any of the materials
and equipment mentioned in this book, please visit the
Search Press website:
www.searchpress.com

Publisher's notes
All the step-by-step photographs in this book feature the author,
Noel Gregory, demonstrating his acrylic painting techniques.
No models have been used.

**Please note: when removing the perforated sheets of tracing paper
from the book, first score them, then carefully pull out each sheet.**

Share your *Ready to Paint* artworks with the world. Simply go to the
'Ready to Paint' page on Facebook and upload your images.

Printed in China

Dedication
To Sue, my partner, whose kindness and
patience has enabled me to carry on painting,
learning and getting better all the time.

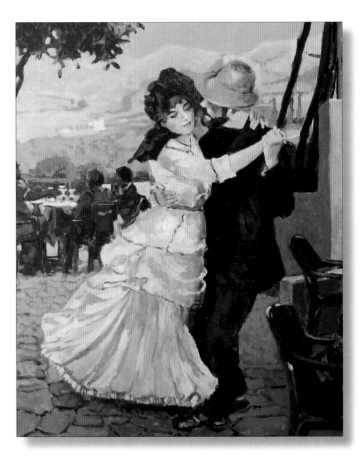

Acknowledgements
To all at Search Press, who, through encouraging
my writing, have increased my knowledge and
appreciation of the Masters, and so helped
develop my own work.

Page 1
Lady With Parasol in Garden
38 x 56cm (15 x 22in)

*This version of Renoir's 1875–76 original appears as a step-by-step
demonstration on pages 12–21.*

Above
**Detail of the dancers from *After the Luncheon of the
Boating Party***
100 x 81cm (30 x 32in)

*This detail is taken from a composite painting of mine that uses the
dancers from Renoir's famous* Dance at Bougival. *The full painting
can be seen on page 64.*

Contents

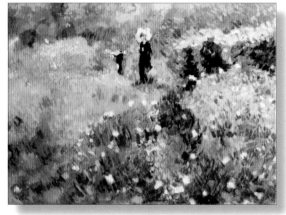

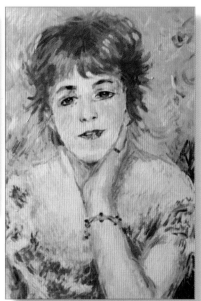

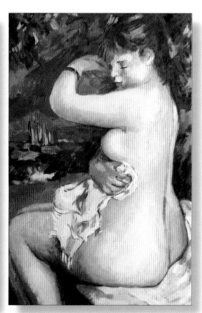

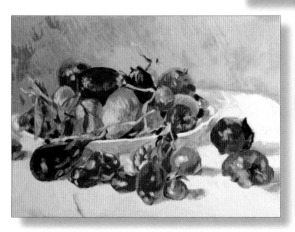

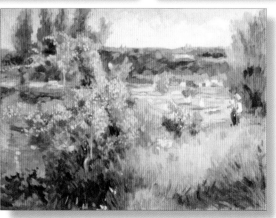

Introduction

When I came to write this book, I found choosing just five of Renoir's works to represent the Master's oeuvre difficult, due to the many changes of style and technique that this artist used in his lifetime. In addition, some of Renoir's large, important works like *Dance at Bougival* and *Luncheon of the Boating Party* are beyond the scope of this size of work. However, with such a wealth of material to use, I had great pleasure selecting pictures that are both inspirational and practical for the approach I use in this book.

Copying the Masters gets you in the mood for greatness. Learning how Renoir may have used his colours and images is the best way to understand his work and inform your own art. However, it is not always possible or practical to view Renoir's original paintings in order to copy them, so using reproductions and art books from libraries and the internet to inform your colour choice is important.

The Impressionist movement is still enjoying great success today, with the artists' techniques, colours and subjects reflected in modern figurative painting, and some of the highest prices ever paid coming from the world's art auction houses for their work. They have, put simply, shown us the way to picture-making.

Publisher's note

In addition to the five projects in the book, a bonus tracing is provided for the painting shown opposite, so that you can have a go once you feel confident with the techniques and use of colour shown in the other projects. You can find the tracing at the end of the pull-out section.

TRACING

6

The Umbrellas

66 x 91cm (26 x 36in)

Depicting a group of figures on a rainy day in the streets of Paris, the original was completed over a number of years and is one of the most iconic of Renoir's paintings. It was recorded to have been started in 1881, and the influence of the French artist Ingres on Renoir resulted in the figures on the left-hand side being repainted with more precise drawing and greater subtlety of coloration between 1885 and 1886. The original measures 115 x 180cm (45¼ x 70¾in) and now hangs in the National Gallery, London, UK.

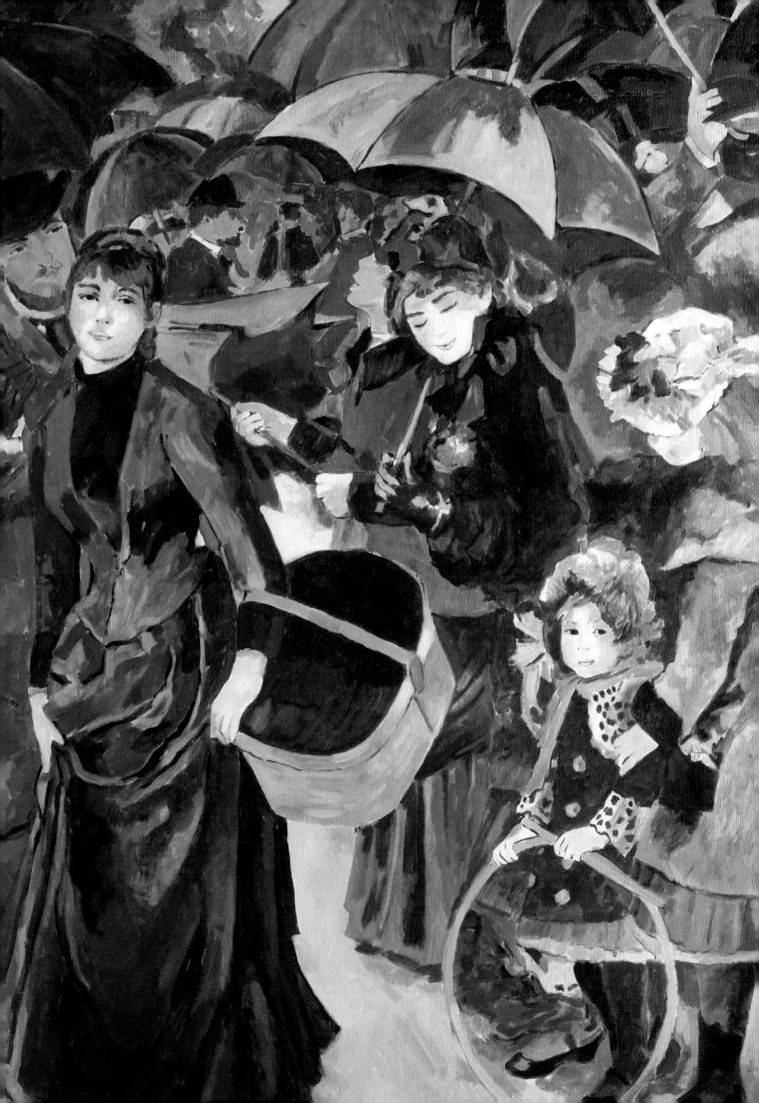

Pierre-Auguste Renoir

Pierre-Auguste Renoir was one of the leading exponents of Impressionism, an art movement that included Monet, Sisley, Bazille and a host of others. Six of Renoir's works were hung in the first exhibition of the *Société Anonyme Coopérative des Artistes Peintres, Sculpteurs, Graveurs* (Cooperative and Anonymous Association of Painters, Sculptors, and Engravers), a group set up in opposition to the established and conservative *Salon de Paris* in 1874. A critic at this exhibition was to deride the work of the artists as only an 'impression', a play on words on one of Monet's exhibits, entitled *Impression, Sunrise*. This derogatory comment was taken up defiantly as a badge of honour by the young group, and led to the naming of one of the art world's most famous movements.

In 1862, at the age of twenty-one, Renoir came to paint in Paris under his first master, Charles Gleyre. At this point in his life, the young artist rarely had enough money to buy paint, but he was eager, and was often seen studying the French Masters in the Louvre. After travelling widely in Europe and being influenced by the works of Titian, Delacroix and Velázquez, whose techniques would stay with him for the rest of his life, Renoir first exhibited his work in 1864.

Renoir used light and saturated colour to great effect in his work. His compositions of people were often large canvases depicting crowds of people with subtle use of dappled light and great movement. His early paintings were greatly influenced by Corot, Courbet and Manet. Like these artists, Renoir used black paint during this early period of his career. However, by the late 1860s, Renoir had abandoned black, instead painting shadow areas with the reflections of the colours of surrounding objects, a technique that showed the diffuse reflection of light.

The period 1881–1890 saw Renoir's career develop, and many of his most famous paintings completed, including *Luncheon of the Boating Party* at the start of this period. Whilst living in Montmartre, Renoir employed a young model called Suzanne Valadon. She posed for many of his works, including the iconic *Dance at Bougival* and *The Bathers*, and went on to

become a leading artist in her own right. In 1887, Renoir donated several paintings to Queen Victoria's Golden Jubilee celebrations on the request of Phillip Richbourg, the Queen's associate. Three years later, Renoir married Aline Victorine Charigot, the model who had posed for the splendid *Luncheon of the Boating Party*.

In later life, Renoir developed rheumatoid arthritis and moved to a warmer climate on the Mediterranean coast to ease the pain. However, his condition continued to worsen, eventually necessitating an assistant to put brushes in his hands to allow him to paint.

Renoir lived long enough to see his paintings hang with the Old Masters, and he died in the village of Cagnes-Sur-Mer, Provence-Alpes-Cote d'Azur on December 3rd 1919. He left several thousand paintings, and the sensuality of style has led to his works being some of the best-known in the history of art.

Pierre-Auguste Renoir

The Master, pictured in 1898, from the Collection of Annette Vaillant.

© *The Art Archive/Marc Charmet*

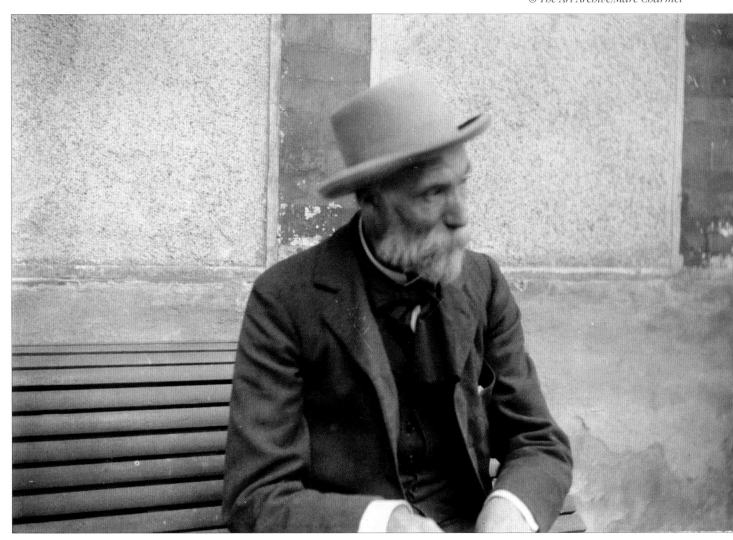

Materials

Paints

Renoir mainly used oil paints, and his son reported that the Master's palette was fairly small, consisting of 'silver white, chrome yellow, Naples yellow, ochre, raw sienna, vermilion, madder red, Veronese green, viridian, cobalt blue [and] ultramarine blue.' Acrylic paints are readily available nowadays. They match the hues of Renoir's oils closely and are both clean and simple to use, which makes them perfect for the projects in this book.

I have used the following palette of acrylic paints in this book: cadmium yellow medium, cadmium orange, cadmium red deep, cerulean blue, ultramarine blue, titanium white, alizarin crimson, dioxazine purple, phthalo blue (green shade), viridian and Hooker's green. This selection provides a good basic palette with a range of interesting hues.

A variety of acrylic paints in tubes.

Surfaces

I have used canvas boards for the paintings in this book. These are hardboard with canvas attached, which makes them both easy to work with and economical. Box canvases are a good alternative, and you may find them an easier, less rigid surface on which to paint.

Whichever you choose to use, remember that if you can not get the exact size that the book requires, any larger one will suffice. Leave a border round the outside and transfer the tracing in the centre.

A box canvas (top) and canvas board (bottom).

Brushes

It is not necessary to have hundreds of different brushes. You need a spread of different sizes, but other than this guideline, you should work with whichever type you find most comfortable.

The projects in this book can be painted with just five brushes: a size 10 long filbert, for adding in the underpainting and other large areas of colour; a size 6 short filbert and size 2 short flat/bright for the bulk of the work; and a pair of detail brushes, such as the size 2 and size 1 sable round brushes I use here for fine detail and finishing work.

From left: size 2 round, size 1 round, size 10 long filbert, size 6 short filbert, size 2 short flat/bright.

Other materials

Palette I have used simple stack palettes and a tin plate. These will give ample mixing areas for these small pictures.

Pencil A 2B pencil is used to transfer the image, and an **eraser** is useful in case you want to fix any mistakes. An empty ballpoint pen makes a good alternative to the pencil for step 2 of transferring the image (see opposite).

Kitchen paper This is used for cleaning brushes when changing between colours.

Water pot A supply of clean water is always essential. An ordinary glass tumbler was used in this case, but any heavy glass jar is acceptable.

Hairdryer A hairdryer is used to speed up the drying between layers of paint.

Retarding medium This is added to acrylic paints to give a little extra working time when blending colours. Use it only if you feel you need the extra time.

Easel I always use an easel for my painting. A huge choice is available from any suppliers of art materials.

Transferring the image

It could not be easier to pull out a tracing from the front of this book and transfer the image on to canvas board. You should be able to reuse each tracing several times if you want to create different versions of the scene.

Tip

It is possible to use a suitably-sized sheet of carbon paper to eliminate the first step. Simply place it between the tracing and your canvas, and use a sharpened pencil to transfer the image.

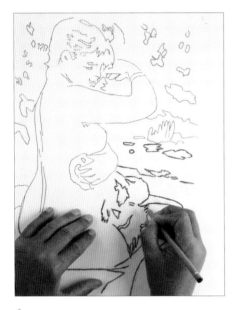

1 Draw on the reverse of the tracing with a 2B pencil.

2 Turn the tracing right side up and place it face up on your board using masking tape. Use a pencil to go over all the lines of the tracing. If you are right-handed, work from left to right so as not to smudge what you have already drawn, and vice versa if you are left-handed.

3 Lift up the tracing and you will see the drawing beginning to appear on the canvas board. Do not worry if it looks faint; if it is too strong, the graphite can smudge during the painting process and look untidy. Once the pencil marks are transferred, remove the tracing. You are now ready to paint!

Lady With Parasol in Garden

Painted by Renoir between 1875 and 1876, the original is a typical example of the artist's quick brushwork, resulting in a build up of colours and tones that represents the dappled light effects on the garden beautifully. I have followed a similar approach in this step-by-step project.

The original measures 65 x 55cm (25½ x 21½ in) and can be viewed in the Thyssen-Bornemisza Museum of Art in Madrid, Spain.

You will need

Canvas board 56 x 38cm (22 x 15in)

Colours: viridian, ultramarine blue, cadmium yellow medium, titanium white, alizarin crimson, cadmium orange, cadmium red deep, cerulean blue, Hooker's green, dioxazine purple

Brushes: size 10 long filbert, size 6 short filbert, size 2 short flat/bright, size 2 round

1 Transfer the image, following the instructions on page 11, then use the size 10 long filbert to apply dilute viridian over the whole painting as an initial wash.

2 Add some ultramarine blue to the viridian and block in some initial dark areas.

3 Use the size 6 short filbert to apply a mix of cadmium yellow medium and titanium white over the light areas.

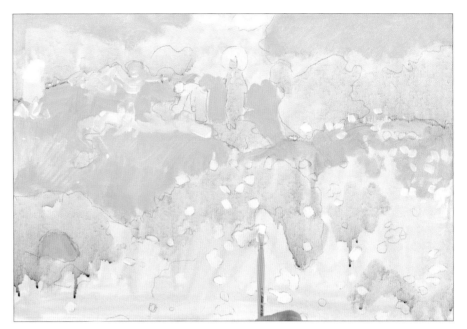

4 Use the size 2 short flat/bright to apply pure titanium white to the painting, picking out the flowers.

Tip

Using pure white at the early stages of a painting can establish where the most important parts of a painting are in relation to one another. This helps the rough underpainting to be understood more easily.

5 Make a deep mix of ultramarine blue with a little alizarin crimson, and block in the darkest areas using the size 2 short flat/bright. Dilute the mix a little to let some of the underpainting through.

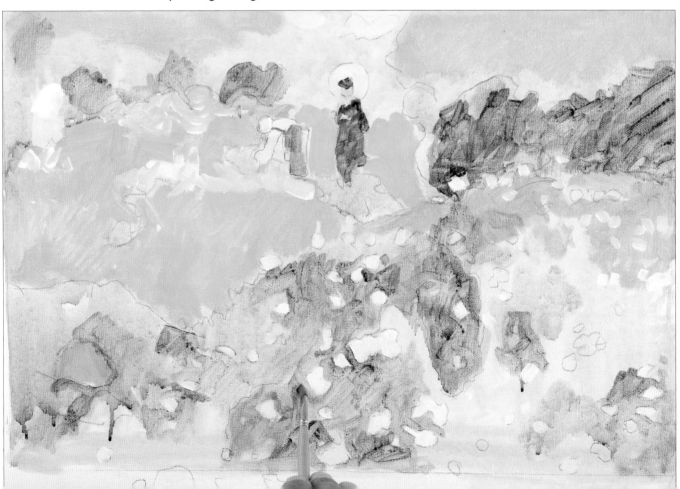

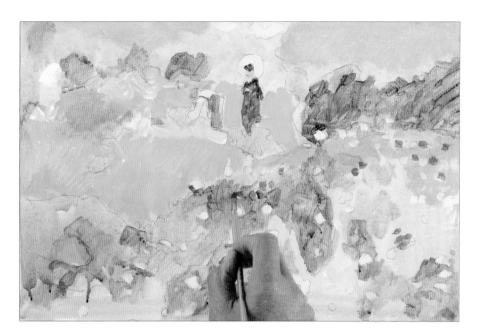

6 Apply a mix of cadmium orange and cadmium red deep to pick out the red hotspots and warm areas.

7 Scumble a mix of titanium white and cerulean blue over the sky and flower areas as shown with the size 6 short filbert. Use the paint a little thicker than before, but allow some of the underpainting to show through between the strokes.

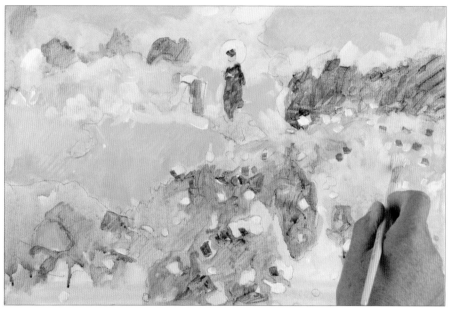

Note

Scumbling is the technique of using drier paint to overlay previous colours. This creates a broken effect that lets some of the previous layer show through, adding texture.

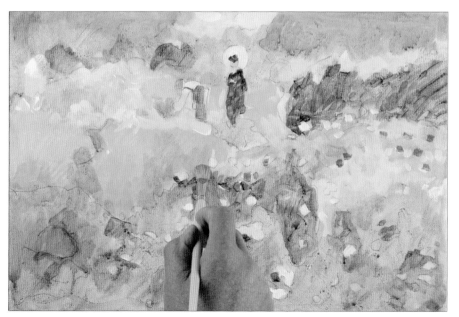

8 Use a very dilute wash of viridian to glaze the green areas at the edges, then dilute further to glaze the green areas in the centre.

9 Still using the size 6 short filbert, begin to darken the blue areas using a mix of cerulean blue and viridian. Use smaller, tighter strokes than before.

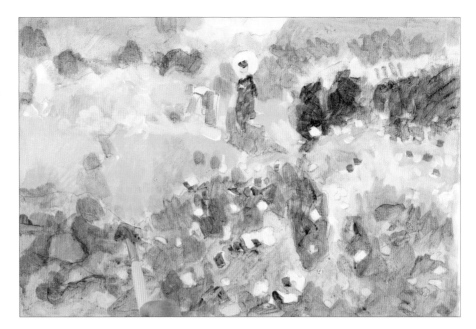

10 Mix cadmium yellow medium, titanium white and a little Hooker's green. Use the size 2 short flat/bright to break up the blocked-in areas of the underpainting with multiple short strokes of this light mix. Use the same mix for the face of the girl with the parasol.

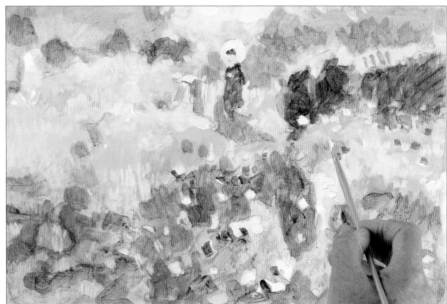

11 Add some brighter highlights across the background foliage using pure titanium white, and apply some of the same mix to the parasol and foreground flowers.

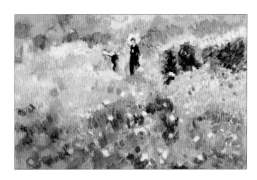

19 Add titanium white and cadmium orange to the light green mix, and use the resultant mix to repeat the process, adding it across the painting to suggest light shining through leaves and picking out mid-tones in the garden.

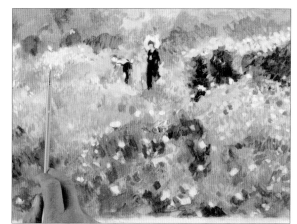

20 Add tiny touches of pure titanium white to reinforce the lighter areas using the size 2 short flat/ bright. Save the smallest marks, made with the corner of the brush, for the background, and use slightly longer strokes in the foreground.

21 Mix viridian with a little dioxazine purple, and use this to further develop the mid-tone and dark areas. Again, use longer strokes at the front, and smaller ones at the back.

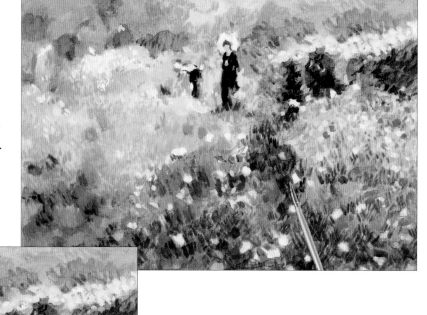

22 Mix Hooker's green with titanium white, and use this acid green with the size 2 round to add a few brushstrokes across the bright area in the left midground, and around the left-hand figure.

23 Using the size 2 short flat/bright with a combination of titanium white and ultramarine blue, add in some touches of light blue, overlaying the underpainting.

24 Add some more titanium white to the mix and add variation to the same areas. Mix a tiny touch of Hooker's green and still more titanium white into the paint and lightly touch in grey-green strokes across the garden.

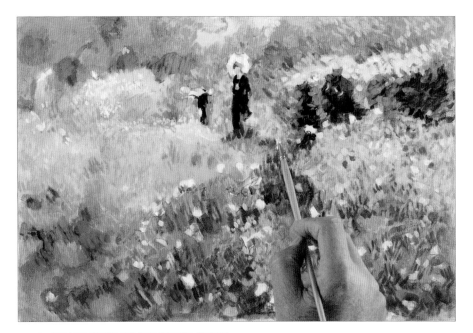

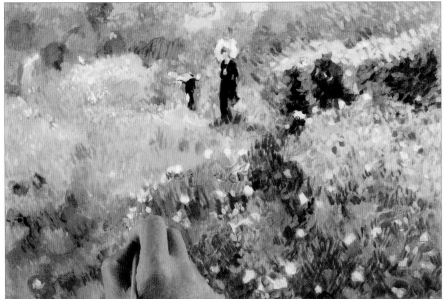

25 Use a mix of cadmium orange, viridian and plenty of titanium white to add very light touches across the painting, concentrating on the background foliage and the grasses on the left. Use almost dry paint, and an extremely light touch, so some of the underpainting shows through.

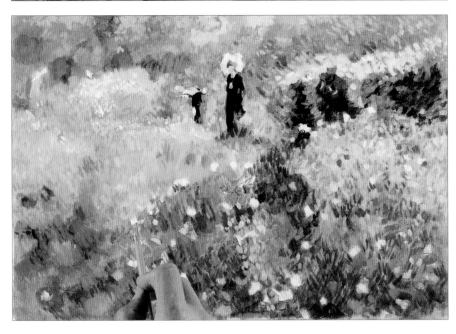

26 Repeat the same process, using a mix of titanium white and cadmium yellow medium for sunlit points. Make any additions you feel necessary to finish.

Overleaf

The finished painting.

Portrait of Actress Jeanne Samary

TRACING
2

This is another example of Renoir's dappled approach to painting, with the paint applied almost like make-up: the foundation is applied, then flicks of surface colour are added, giving vitality and vibrance to the portrait. The original of this small canvas, which measures just 46 x 56cm (18 x 22in), was painted in 1877. It now hangs in the Pushkin Museum in Moscow, Russia.

You will need

Canvas board 38 x 56cm (15 x 22in)

Colours: titanium white, cadmium yellow medium, cadmium orange, cadmium red deep, viridian, ultramarine blue, alizarin crimson, dioxazine purple

Brushes: size 10 long filbert, size 2 short flat/bright, size 2 round, size 6 short filbert, size 1 sable round

1 Transfer the image to canvas board, following the instructions on page 11, then make a dilute wash of titanium white mixed with a little cadmium yellow medium and cadmium orange. Cover the whole painting using the size 10 long filbert.

2 Add a little cadmium red deep to the mix and block in the background using the same brush. Use the same colour on the shaded areas of the face and skin.

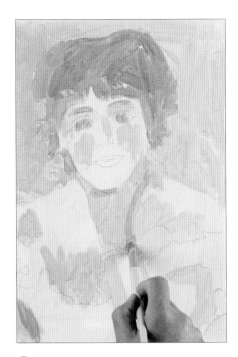

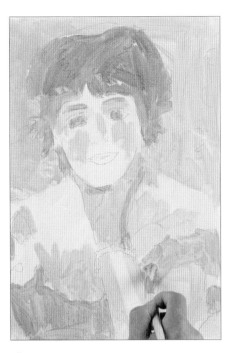

3 Mix viridian with cadmium orange, and block in the hair. Use the blade of the brush to touch in the eyebrows, eyes and the shadows on the hand.

4 Use a mix of viridian and titanium white to lay in the underpainting of the model's dress.

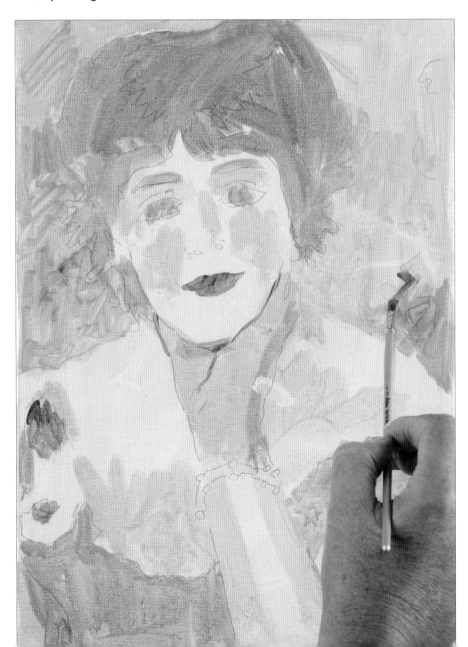

5 Switch to the size 2 short flat/ bright and paint in the model's lips with a dilute mix of cadmium red deep and cadmium orange. Use the same mix to pick out warmer areas of the background, dress and hand.

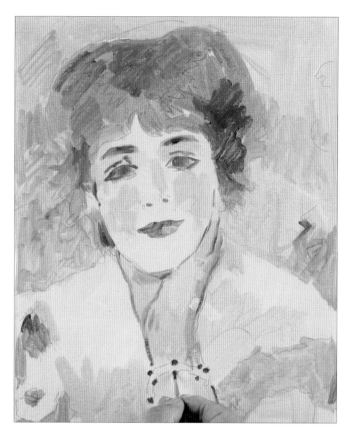

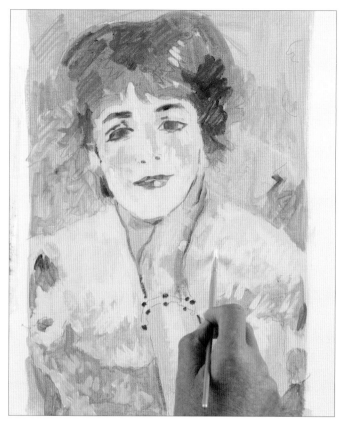

6 Create a fairly thin mix of ultramarine blue, cadmium red deep and viridian for a dark tone. Use the size 2 round to carefully paint in the eyelids and eyes. Strengthen the hair and insides of the eyebrows with the same mix. With a dryish brush, reinforce the lines on the hands and neck as shown.

7 With the initial dark tones and mid-tones in place, use the size 2 short flat/bright to begin to place the initial highlights. Use a skin mix made from titanium white with subtle touches of cadmium yellow medium and cadmium red deep.

Tip
Keep the mix dilute – simply have less of it on the brush for the hands.

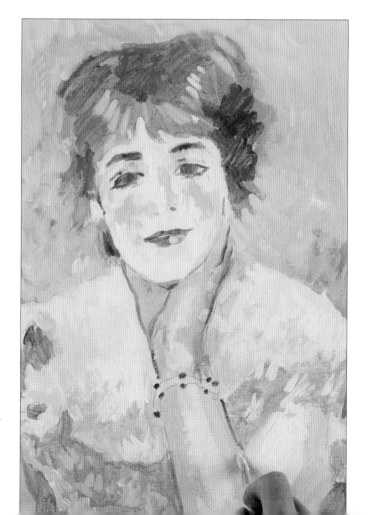

Tip
The original painting has virtually no drawing apparent, so the short, quick, flurried strokes made in these steps need to cover the lines made earlier.

8 Add alizarin crimson to the skin mix and use the size 6 short filbert to create a warming flurry of pink strokes in the background, and subtle touches on the skin. Use the same quick, short strokes as before.

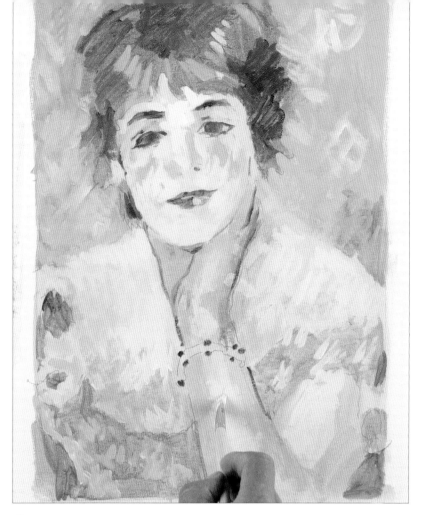

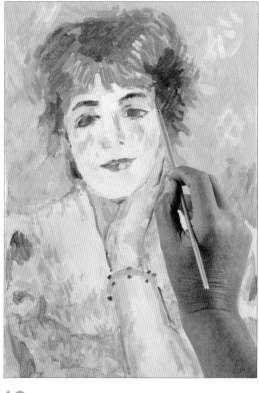

9 Add plenty of titanium white to make an ivory flesh tone and use slightly more controlled strokes to build up the model's skin, overlaying some of the previous strokes. Add a few touches of the colour to the background, in order to tie the different elements together.

10 Make a warm grey-orange by adding touches of cadmium orange and viridian to titanium white. Use the size 2 short flat/bright to apply it to suggest warm areas on the model's skin and hair. Concentrate on the edges of the hair, and an arc across the front, as shown, to suggest light catching at the sides and front. Use the same mix for her bracelet.

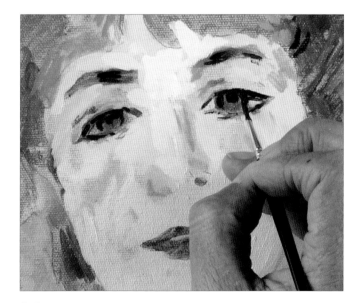

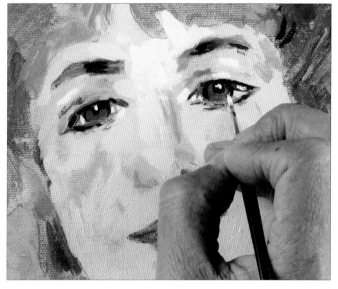

11 Use a very dark mix of viridian, ultramarine blue and alizarin crimson with the size 1 sable brush to reinforce the darkest areas of the eyebrows. Paint strong, fine lines across the upper eyelids and the outer parts of the lower eyelids. Use the same mix to paint the top halves of the pupil and iris areas.

12 Use viridian with a touch of titanium white and paint in the lower part of the irises, then use pure titanium white to add a delicate touch of reflected light at the top right of each eye, to suggest their roundness and glossiness. Use any white paint left on the brush to make the irises subtly lighter.

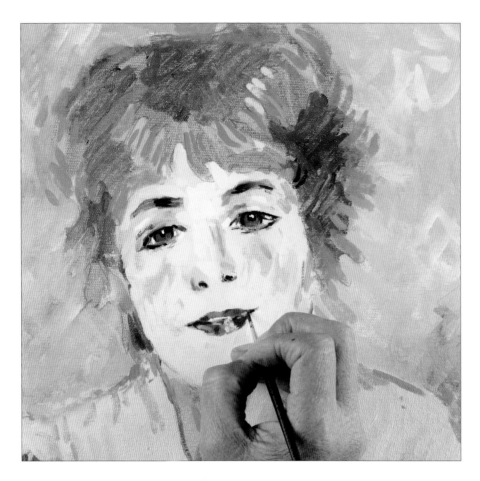

13 Still using the size 1 sable round, tighten the details of the lips with a mix of cadmium red deep and titanium white. Delicately add touches at the edges of the nostrils. Use a mix of dioxazine purple and alizarin crimson to touch in the nostrils and the very corners of the mouth.

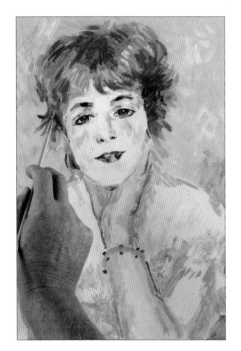

14 Use a dark mix of viridian with a little cadmium orange to add details to the dark areas of the hair with strokes of the size 2 short flat/bright brush.

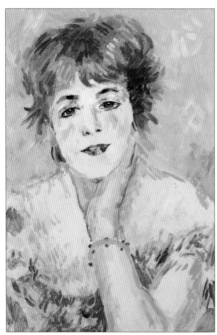

15 With flicking brushstrokes and the size 2 short flat/bright, apply viridian mixed with a touch of white to the dress.

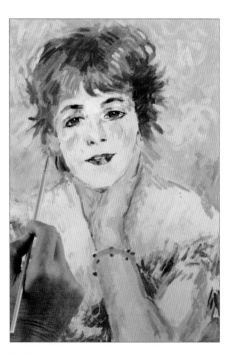

16 Use a pink mix of alizarin crimson and titanium white to add some touches to the background and skin and also to cut into the hair a little.

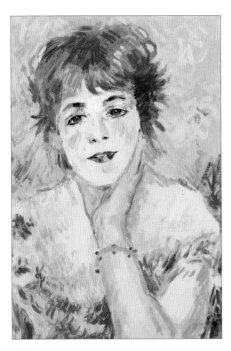

17 Make a reddish mix of alizarin crimson and cadmium orange, and add some warm touches across the background and dress.

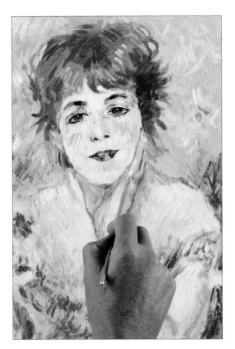

18 Add tiny touches of cadmium yellow medium to titanium white and use it otherwise undiluted to add delicate highlight touches across the skin.

Tip

The paint used here should be very dry; the aim is to catch the texture of the canvas board. If you need coverage, you will need to scrub the paint into the board.

19 Add a little cadmium orange to the mix and develop mid-tone strokes across the painting, with emphasis on softening the face. Add more orange and redefine the edges of the hair.

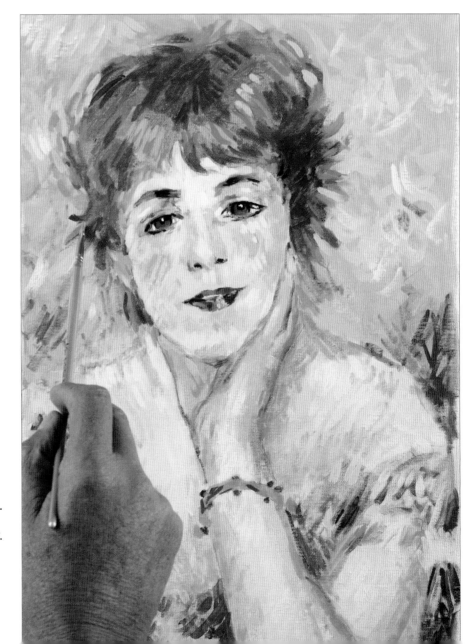

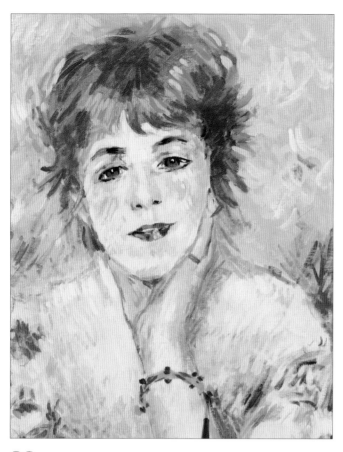

20 Switch to the size 2 round brush and use a warm brown mix of viridian with cadmium orange to paint in some details on the bracelet, add a ring to the model's finger and build up the hair a little more.

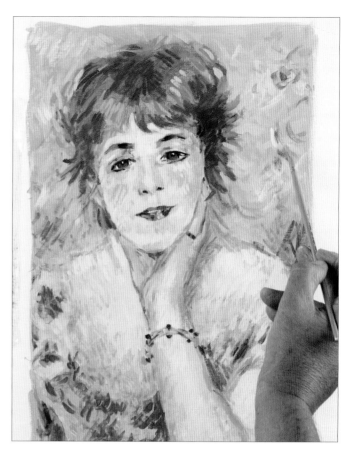

21 Add titanium white to the mix and highlight the bracelet, then apply very dry ultramarine blue to the top of the model's dress and background, using the size 2 short flat/bright brush in little swirling strokes.

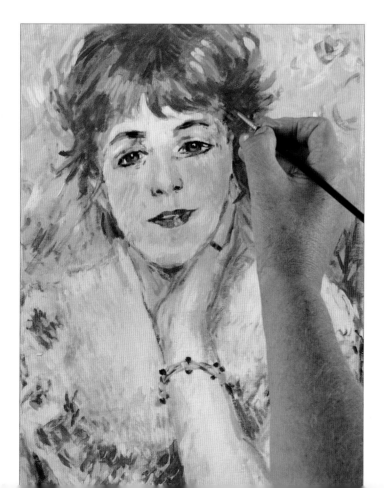

22 Make an olive mix from cadmium orange, viridian and titanium white. Use the size 2 round to add some very subtle touches to the dress, in the shadows of the skin, and in the hair. Make any final changes you feel necessary and allow to dry to finish.

Opposite
The finished painting, reduced in size.

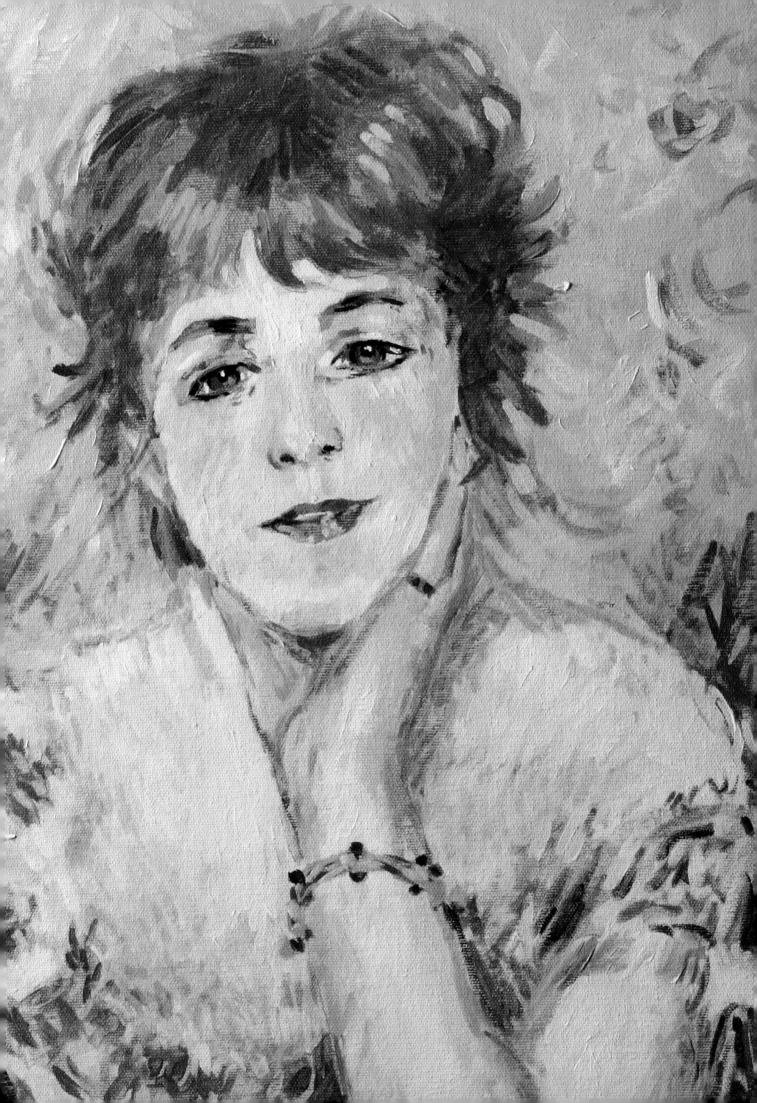

After the Bath

This well-known Renoir image, painted in 1888, shows how the artist represented the sensuality of the feminine form. Renoir's approach followed the tradition of Rubens, and the style was further developed after Renoir by Watteau.

Note how leaving the background slightly out of focus softens the flesh tones of Rose Thao, Renoir's model. The original measures 54 x 65cm (21¼ x 25½in), and is in a private collection in Japan.

You will need

Canvas board 38 x 56cm (15 x 22in)

Colours: cadmium orange, Hooker's green, ultramarine blue, titanium white, cadmium red deep, alizarin crimson, viridian, cadmium yellow medium, dioxazine purple

Brushes: size 10 long filbert, size 6 short filbert, size 2 short/flat bright, size 2 round, size 1 sable round

1 Transfer the image from the tracing to the board, following the instructions on page 11, then use a size 10 long filbert to lay in an underpainting of cadmium orange over the whole canvas. Dilute the paint, and work quickly.

2 Keeping the mix dilute, add Hooker's green to the cadmium orange and block in the background around the figure.

3 Add ultramarine blue to the mix and begin to add in the basic dark areas on the hair, bracelet and background. Keep the paint dilute, like a watercolour.

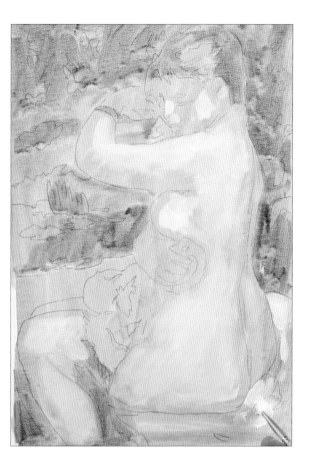

4 Switch to the size 6 short filbert and use pure titanium white to block in the areas of highlight on the figure as shown. Work while the underpainting is still a little damp, so that the white blends into the orange.

5 Still using the same brush and paint, apply thicker areas of titanium white to bring out the strong texture of the towel. Do not use such strong paint that you cover your guidelines.

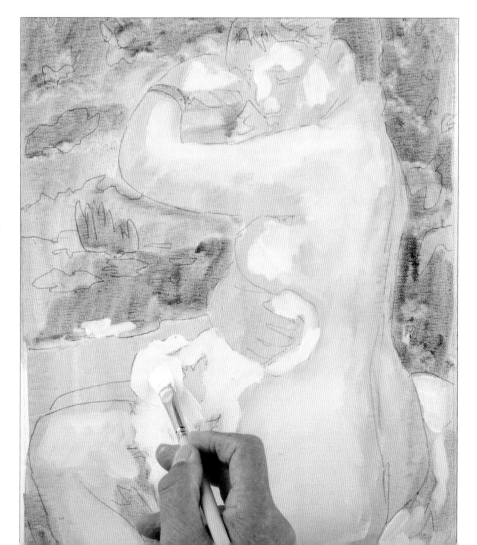

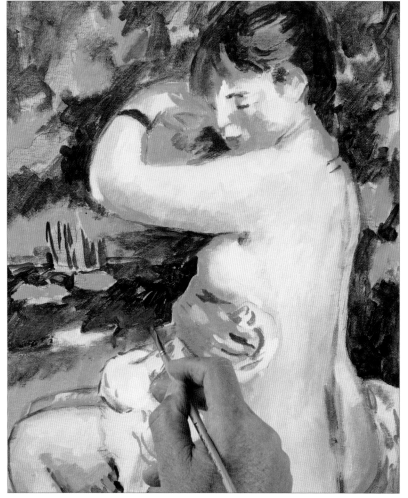

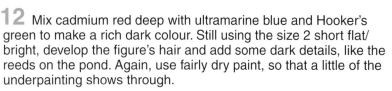

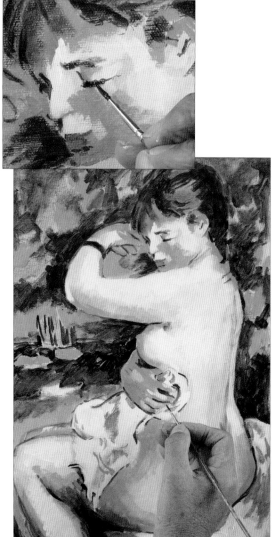

12 Mix cadmium red deep with ultramarine blue and Hooker's green to make a rich dark colour. Still using the size 2 short flat/bright, develop the figure's hair and add some dark details, like the reeds on the pond. Again, use fairly dry paint, so that a little of the underpainting shows through.

13 Switch to the size 1 sable round and use the same mix to strengthen the figure's features (see inset), and to tighten up the outline around the figure and the towel.

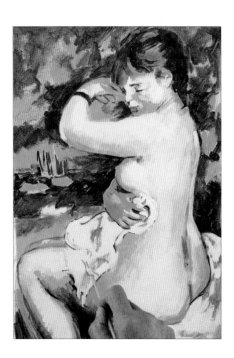

14 Add a tiny touch of ultramarine blue to titanium white and use the size 2 short flat/bright to block in the mid-tones on the towel. Add still more titanium white to the mix, and use the colour to paint the extreme highlights on the figure's skin.

15 Make an extremely dilute mix of viridian and alizarin crimson. Use the size 10 long filbert to apply the mix as a glaze over the whole background to knock it back and blend the colours together a little.

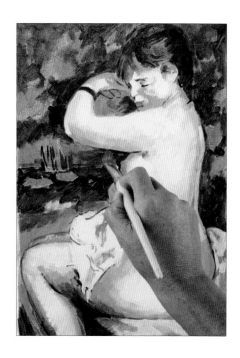

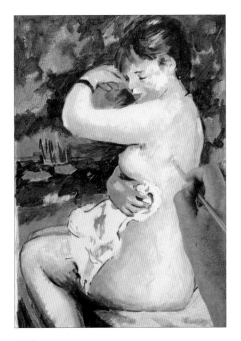
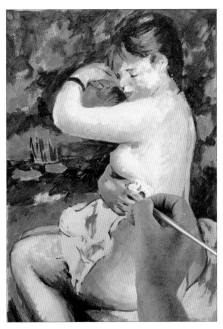
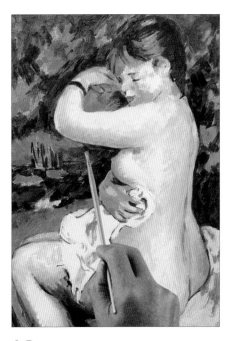

16 Make a flesh tone mix of titanium white with a little cadmium yellow medium and cadmium red deep, and use the size 2 short flat/ bright brush to apply it on the skin areas. Aim to apply it lightly to areas between the highlights, mid-tones and shades already on the skin, so that the colours blend.

17 Add a little cadmium orange to the mix and use it to lightly flick in touches to the foliage in the background, to represent the dappled light. Use the same mix to add some touches to the hair, face and hand.

18 Use a mix of alizarin crimson and viridian to create flecks of colour in the background, using light strokes of the size 2 short flat/bright.

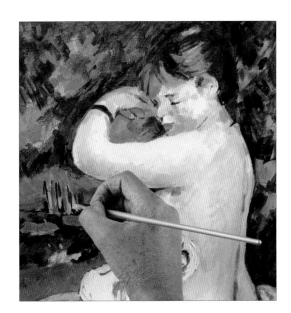
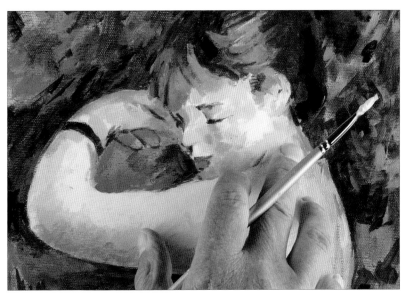

19 Add cadmium yellow medium and a little titanium white to the mix to create a light green. Use this to paint in the reeds by her elbow and to add some more texture to the foliage at the top left.

20 Make a mix of cadmium yellow medium and cadmium orange to titanium white and use the size 2 short flat/bright brush to apply this mix to the face. Smudge the colour into the canvas with your finger to blend different areas together smoothly.

35

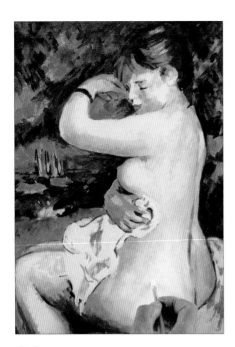

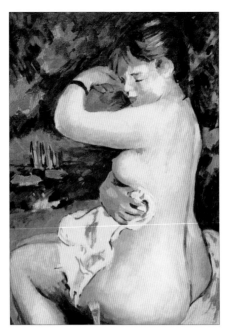

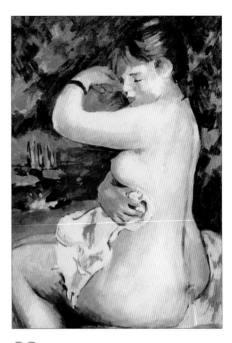

21 Continue applying small areas of the mix over the skin, then smudge them in with your finger. Add more titanium white to the mix and use this for highlights, brushing on tiny amounts of almost dry paint very lightly.

22 Use the size 6 short filbert with very dilute cadmium orange to glaze the areas of skin in shadow, to represent the reflected light. Glaze the area between the towel and left arm with the same subtle orange.

23 Glaze the eyelids with extremely dilute ultramarine blue, then use the same glaze over the shadows at the lower left and down the figure's spine.

24 Add a little ultramarine blue to titanium white and use the size 2 short flat/bright brush to develop the towel.

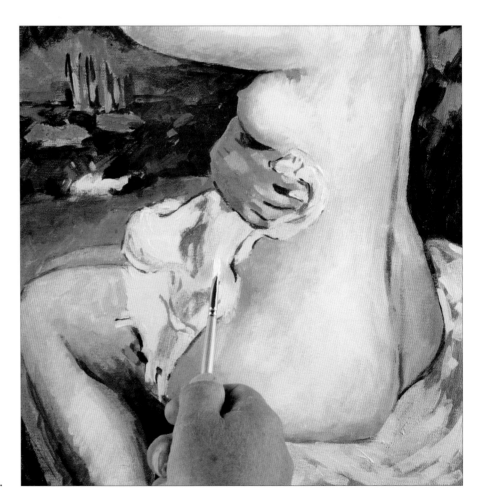

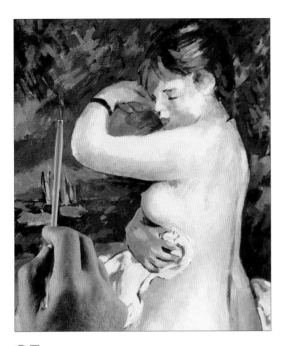

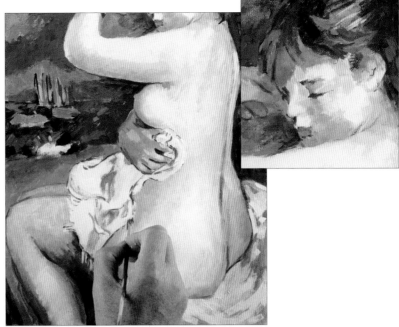

25 Mute some of the dark areas by overlaying them with broad strokes of a mix of viridian, alizarin crimson and titanium white.

26 Add some dioxazine purple to the mix, then switch to the size 2 round and add detail to the towel. Use the same mix to add some fine detail to the face, such as the eyelashes and inside of the ear (see inset).

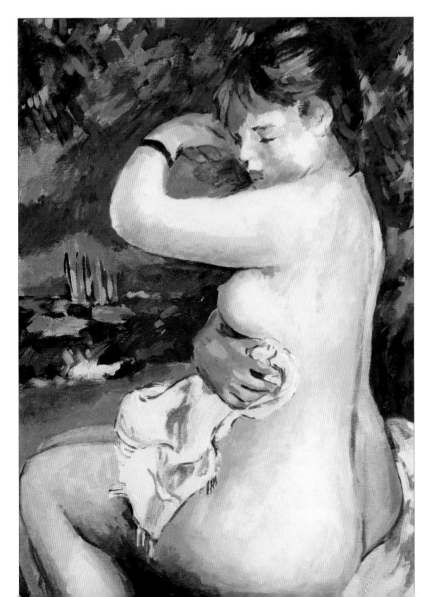

27 Mix titanium white with cadmium yellow medium, then add touches of cadmium red deep and cadmium orange. Use the mix to add some light flicks in the background, suggestive of out-of-focus flowers. Add a little more cadmium orange to the mix and use the mix for more background flowers, and also to add warmth to the skin.

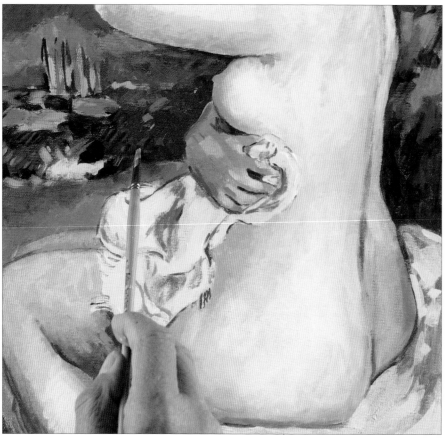

29 Switch to the size 1 sable round and overlay the hair with some subtle strokes of a dark green mix made from viridian and cadmium orange. Use pure cadmium yellow medium for the extreme highlights on the bracelet.

28 Use ultramarine blue and titanium white in varying proportions to add some touches to the water on the left-hand side of the picture. Use the size 2 short flat/bright to apply the mixes. Add a little titanium white and dioxazine purple and add interest to the shadows on the towel.

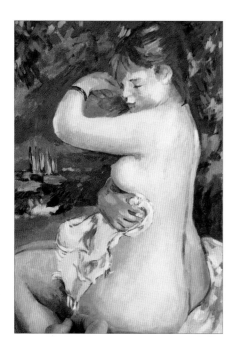

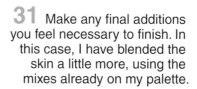

30 Develop the reeds with the size 2 round and a mix of cadmium yellow medium, Hooker's green and titanium white. Use the same brush to pick out some extreme highlights on the towel and skin using pure titanium white.

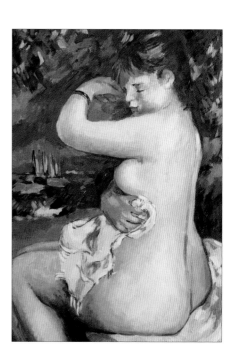

31 Make any final additions you feel necessary to finish. In this case, I have blended the skin a little more, using the mixes already on my palette.

Opposite

The finished painting, reduced in size.

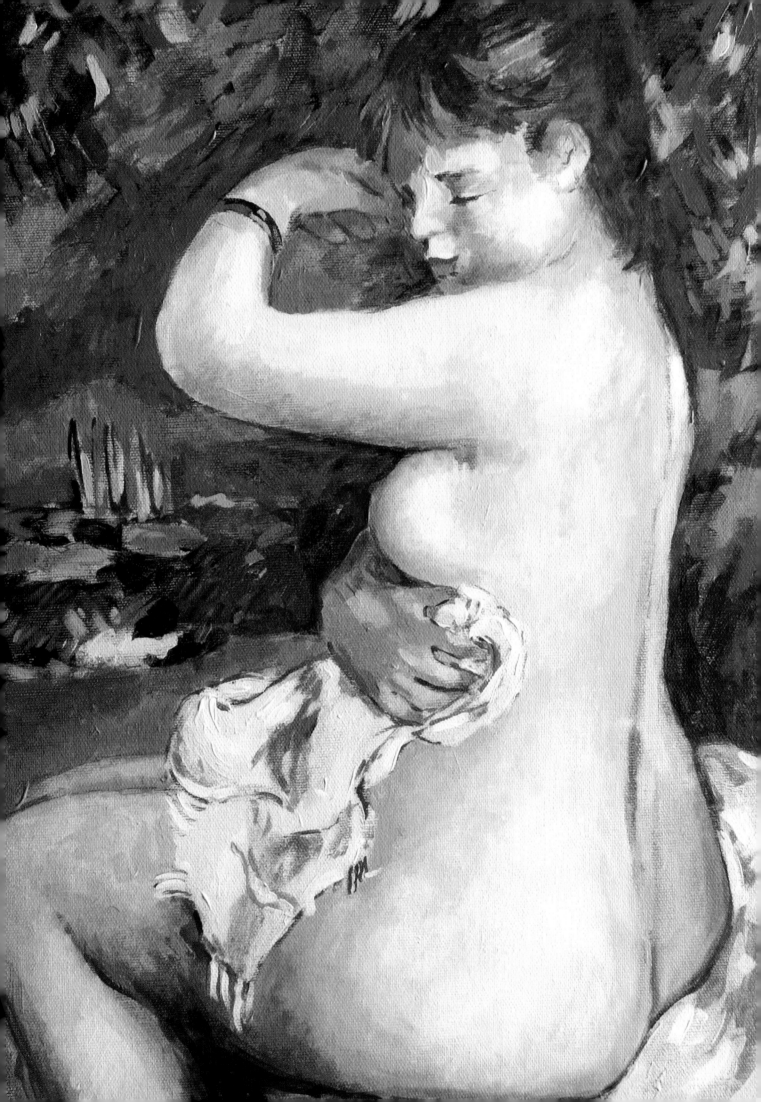

Mediterranean Fruits

The original was painted in oils on canvas, and it measures 65 x 51cm (25½ x 20in). It is thought that Renoir painted this still life when he visited the Mediterranean coast in 1881, and it is typical in style and colour of many of his still life canvases. It now hangs in the Art Institute of Chicago, USA.

TRACING
4

You will need

Canvas board 56 x 38cm (22 x 15in)

Colours: cadmium yellow medium, cadmium orange, cadmium red deep, titanium white, cerulean blue, viridian, ultramarine blue, dioxazine purple, Hooker's green, alizarin crimson

Brushes: size 10 long filbert, size 6 short filbert, size 2 short flat/bright, size 1 sable round

1 Transfer the image to canvas board, following the instructions on page 11. Mix cadmium yellow medium with cadmium orange, and apply a dilute wash over the whole board with the size 10 long filbert.

2 Switch to the size 6 short filbert, add cadmium red deep to the mix and quickly pick out some of the red and orange pieces of fruit.

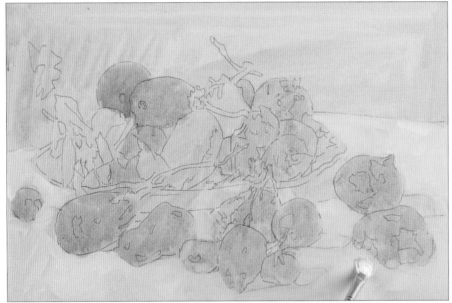

3 While the paint is still wet, pick up a mix of titanium white with a little cerulean blue, and block in the tablecloth.

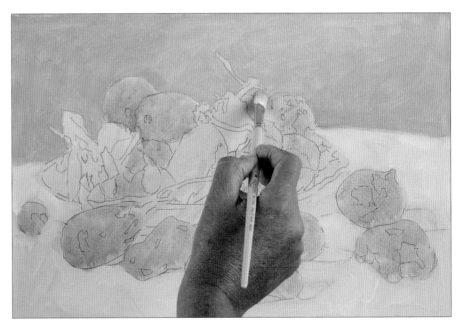

4 Add viridian and a little cadmium red deep to titanium white and use this grey mix to create the underpainting for the background.

5 Still using the size 6 short filbert, add ultramarine blue to the grey mix (titanium white with viridian and a little cadmium red deep). Begin to pick out the shadows on the tablecloth cast by the fruit, and on the underside of the fruit bowl.

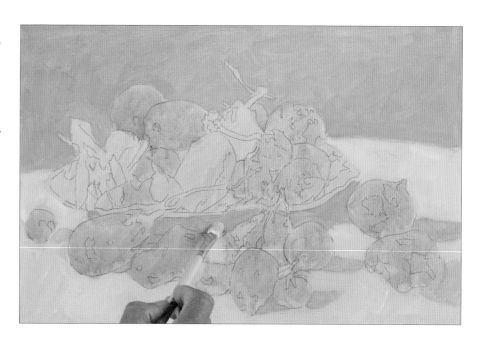

6 Using the size 2 short flat/bright, add dioxazine purple and cadmium yellow medium to the mix, and use this for the dark-toned areas, such as the aubergines, the shaded side of the pomegranate, and the pepper stalks.

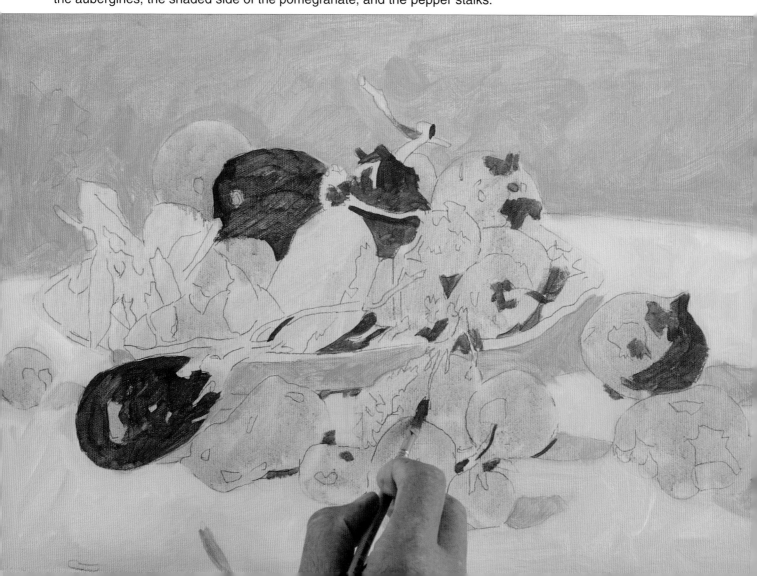

7 Using very dilute cadmium red deep, add in the basic warm areas.

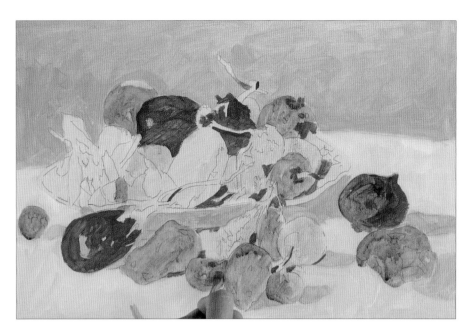

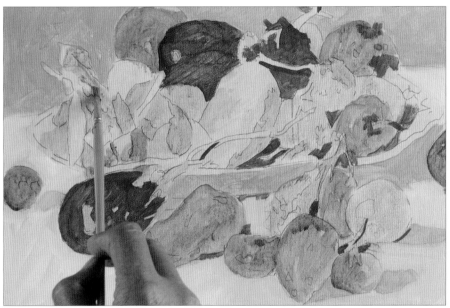

8 Add green touches to the leaves and foliage using Hooker's green.

9 Use light glazes of ultramarine blue to add a gentle hue to the shadows and lay in a base for the blue areas.

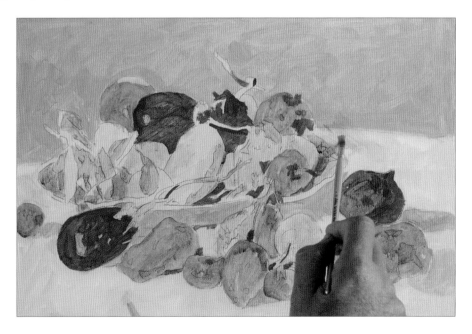

16 Build up the background with medium length crosshatched strokes of titanium white mixed with subtle touches of Hooker's green and dioxazine purple. Vary the proportion of the colours to create interesting hues.

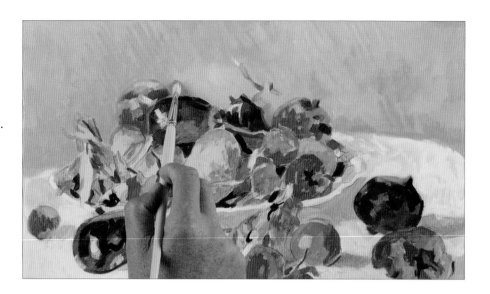

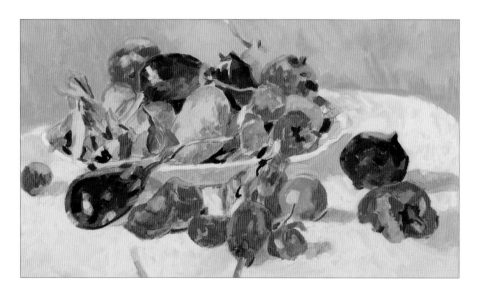

17 Glaze dilute cadmium orange over the fruit, including the aubergines, to show their reflective quality.

18 Mix cadmium red deep with titanium white and pick out the highlights on the fruit.

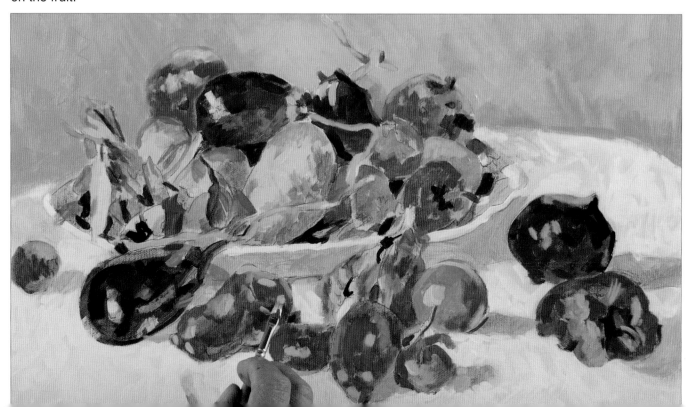

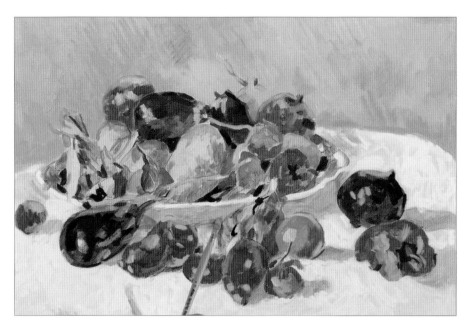

19 Use cerulean blue to add weight and body to the dish, and draw the almost dry brush lightly over the tablecloth and fruit in the shadows.

20 Add subtle drybrushed highlights across the fruit with a mix of cadmium yellow medium and titanium white. Use the same colour, but with considerably more paint on your brush, to add strength to the lemons.

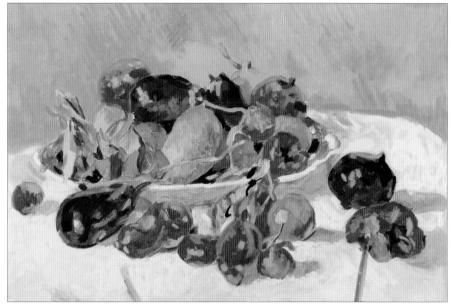

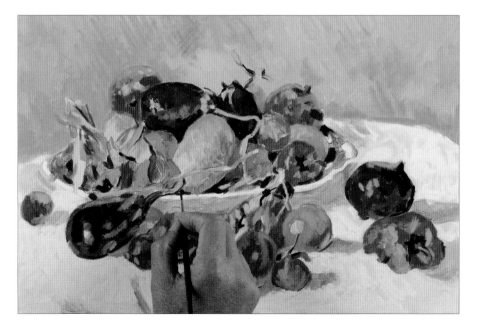

21 Switch to the size 1 sable round and use a mix of Hooker's green and dioxazine purple to carefully re-establish the shapes of the darker fruits.

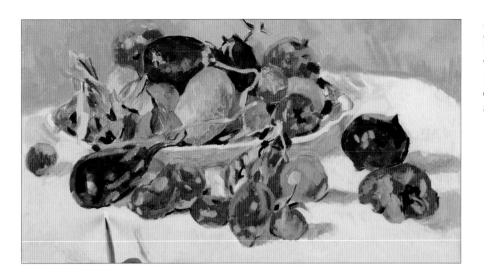

22 Return to the size 2 short flat/bright and use a mix of titanium white with a little cadmium yellow medium to strengthen the coverage on the tablecloth and raise the tone a little.

23 Use the size 6 short filbert to blend the areas of colour together, gently drawing fairly dry cadmium orange over the individual fruits. This helps to harmonise the elements.

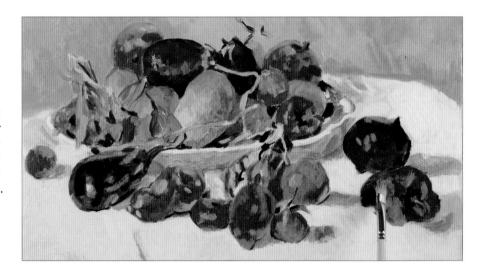

24 Re-establish the highlights on the fruits with very dry paint applied gently and sparingly. Use a mix of titanium white and cadmium yellow medium.

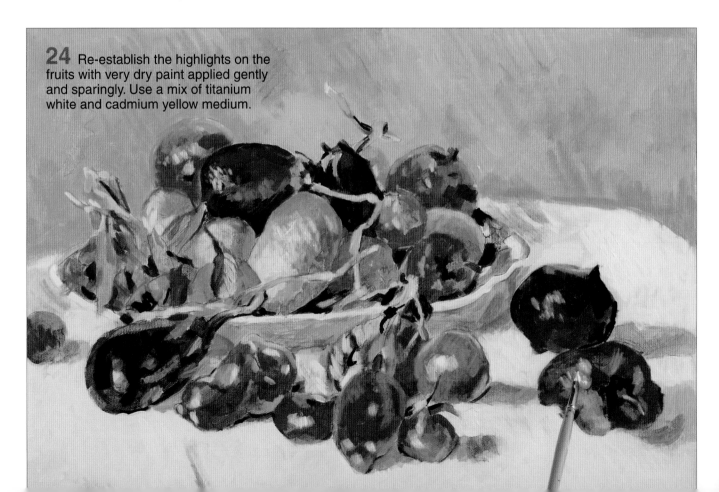

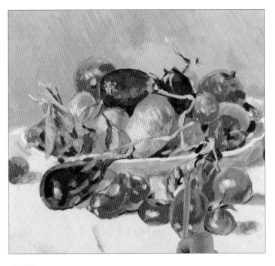

25 Add Hooker's green to the mix and develop the tonal structures on the leaves and stalks.

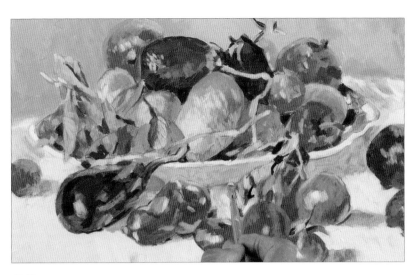

26 Mix dioxazine purple with titanium white, and use this lilac mix to build up the dish.

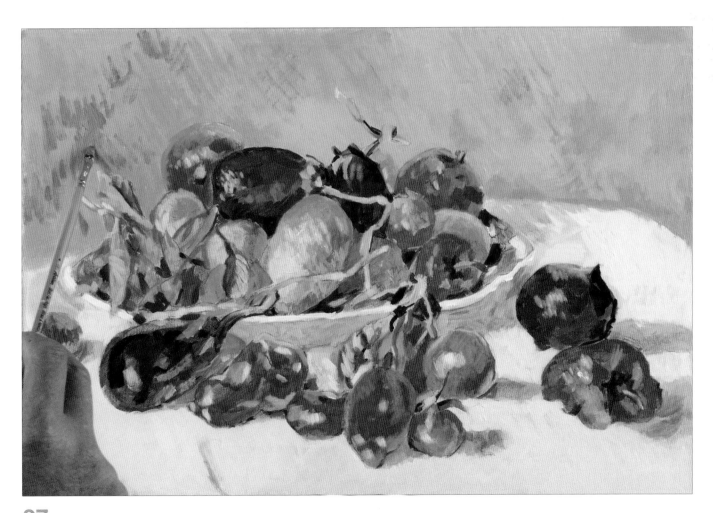

27 Use pure titanium white to build up the dish's lip, then add some touches of a Hooker's green and cadmium red deep mix in the background. Use the same olive mix to add touches to the greenery and shadows.

Overleaf

The finished painting.

49

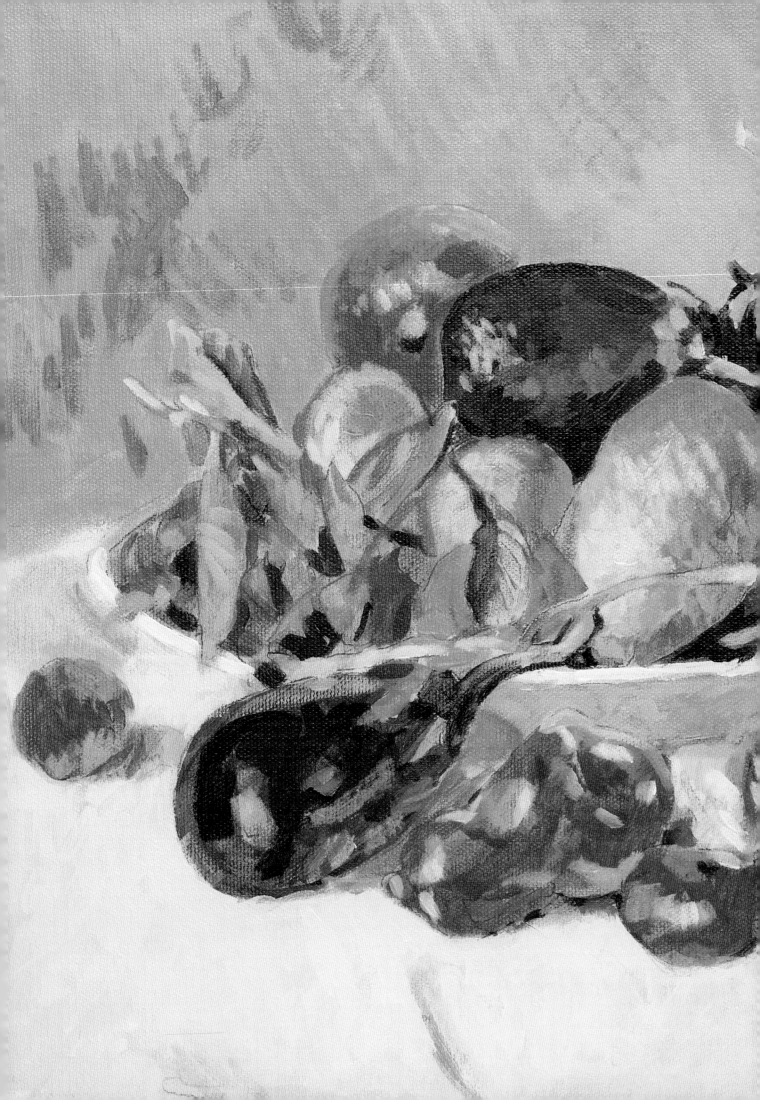

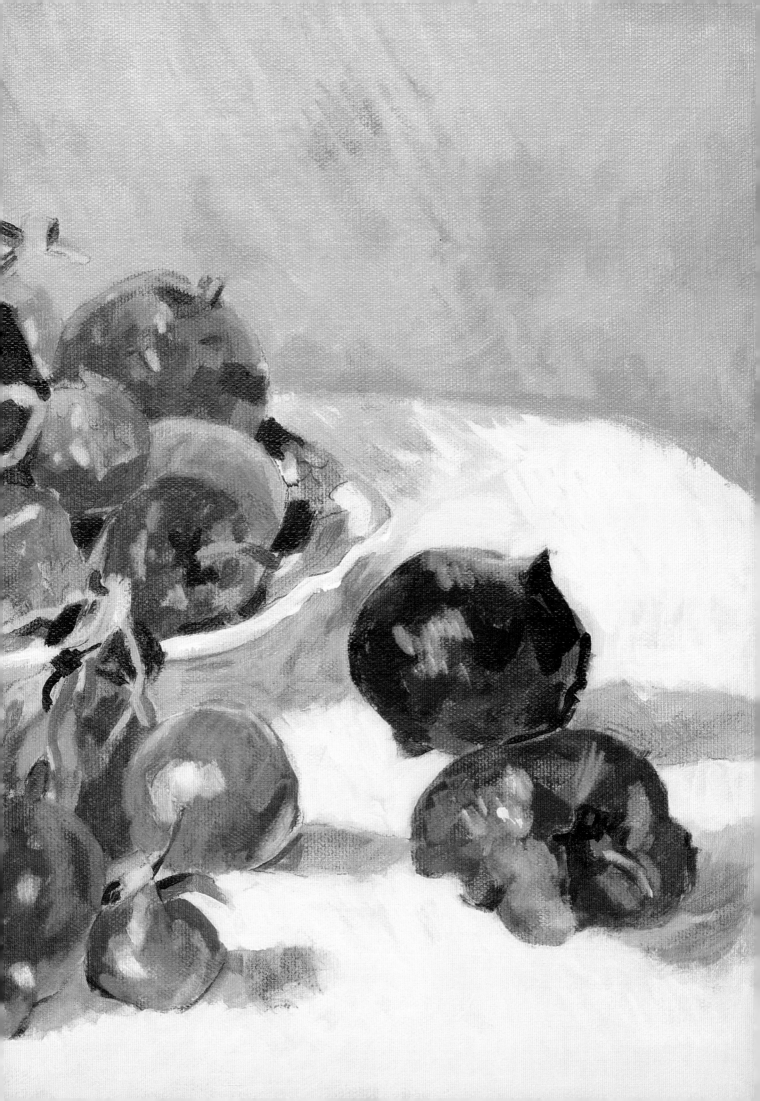

The River Seine at Chatou

This painting shows Renoir at his Impressionistic best, with small brushstrokes and the build up of paint so typical of the movement. This is a great painting to copy because it only needs to be shown as a series of brushstrokes, and will look good even if it is not completely accurate. The original hangs in the Boston Museum of Fine Arts, USA. It measures 65 x 51cm (25½ x 20in) and is similar in size, colour and composition to *Lady With Parasol in Garden*. Like many of Renoir's paintings of this period, it shows little detail: the figure serves mainly as a compositional focal point, and to give a sense of scale.

You will need

Canvas board 56 x 38cm (22 x 15in)

Colours: cadmium yellow medium, cerulean blue, ultramarine blue, titanium white, alizarin crimson, viridian, Hooker's green, dioxazine purple, cadmium red deep, phthalo blue (green shade), cadmium orange

Brushes: size 10 long filbert, size 6 short filbert, size 2 short flat/bright, size 1 sable round

1 Transfer the image to the canvas board, following the instructions on page 11 (see inset), then begin the underpainting by covering the board with a dilute wash of cadmium yellow medium, applying it with the size 10 long filbert.

2 Add cerulean blue to the dilute cadmium yellow medium to make a green, and block in the main areas of foliage and greenery.

3 Make a dilute mix of ultramarine blue and titanium white, then use the size 6 short filbert to roughly block in the water and sky areas.

4 Mix titanium white with alizarin crimson and block in the warm areas across the painting.

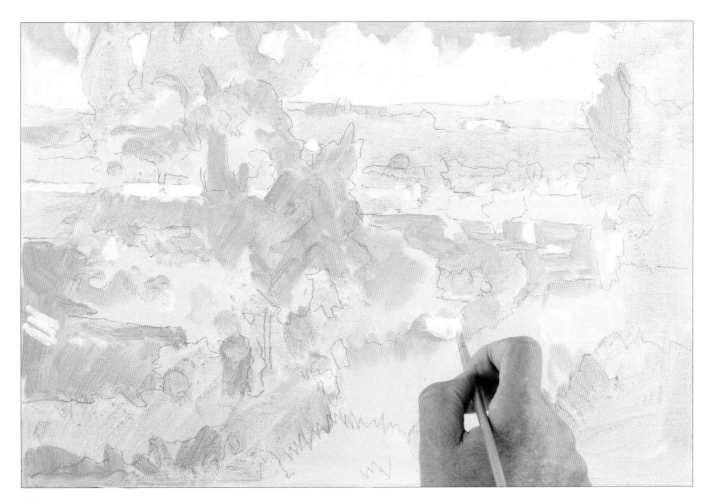

5 Use thicker, pure titanium white to block in the lower area of the sky with the size 2 short flat/bright brush. Use more dilute titanium white to add in lighter touches across the painting.

6 Make a darker mix of viridian with a little ultramarine blue and a tiny touch of alizarin crimson. Varying the proportions for different areas, block in the green areas.

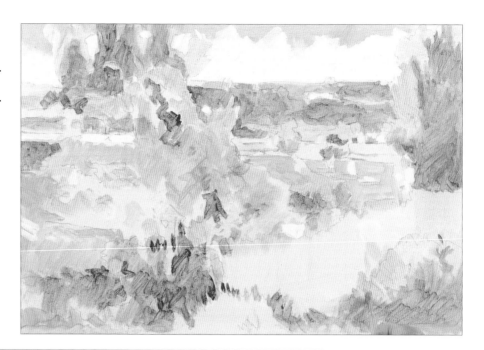

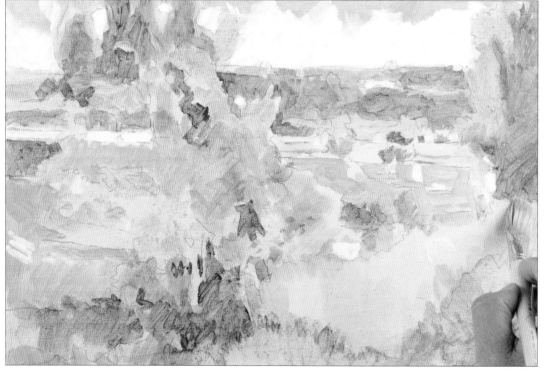

7 Switch to the size 10 long filbert brush and knock back overly-strong areas on the foliage with very dilute Hooker's green.

8 With the size 2 short flat/bright, make a dark mix of viridian, dioxazine purple and a little alizarin crimson. Use short strokes of the brush to create some structure to the foliage.

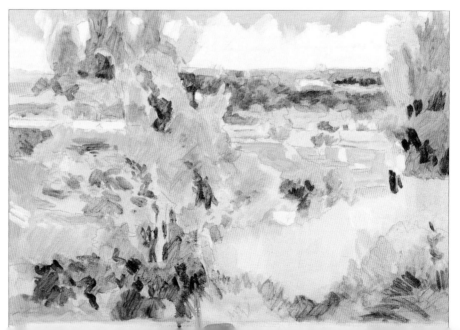

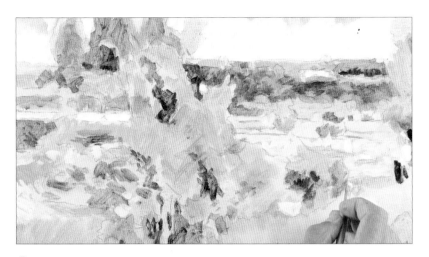

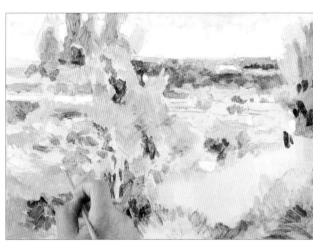

9 Use the same brush to apply a mix of cerulean blue and titanium white to the water in the midground, tightening the area up and creating some structure.

10 Develop the sky with the same colour, then add ultramarine blue to the mix and develop the foreground water.

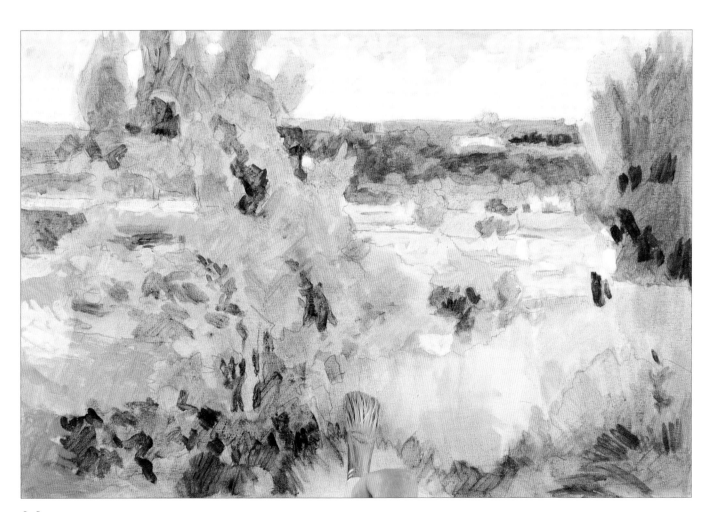

11 Make a very dilute mix of Hooker's green, cerulean blue and a tiny touch of alizarin crimson. Use the size 10 long filbert to glaze the whole picture except the sky and water. This ties the colours together and helps to harmonise the painting.

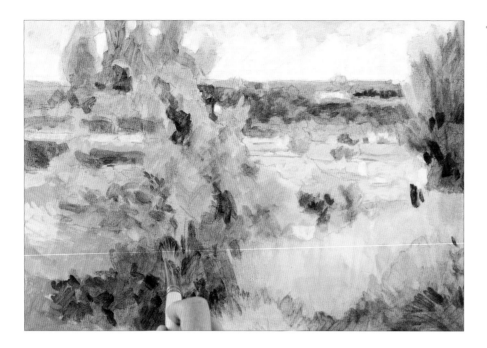

12 Make a slightly less dilute blue mix of dioxazine purple and ultramarine blue, then glaze the areas shown to emphasise their darker tones.

13 Mix titanium white with a hint of alizarin crimson and use the edge of the size 2 short flat/ bright to stipple on details to the midground, suggesting flowers and leaves. Use the same mix with softer, blurrier strokes for the reflections in the water.

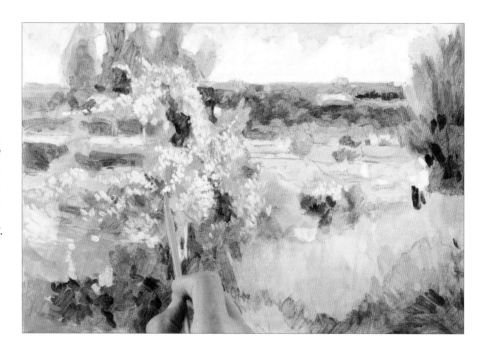

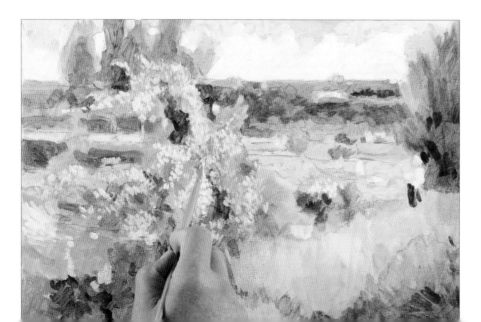

14 Add more alizarin crimson to the mix and touch in the hands and face of the figure on the right-hand side. Use the same mix to repeat the stippling process on the midground, overlaying the white dotted areas to strengthen the suggestion of structure in the tree.

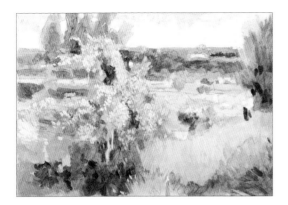

15 Mix titanium white with cadmium yellow medium and use the same brush and technique to stipple yellow areas on to the painting. Use short upright strokes to add some soft yellow areas to the sunlit grass in the foreground with the same mix.

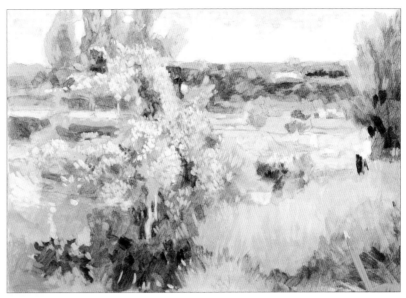

16 Add more titanium white and cerulean blue to the mix to create a pale grey-green, and use stippled strokes on the dark green areas. Use light strokes to build up the background and upright strokes for the lower part of the grasses, partially overlaying the yellow strokes.

17 Add a little cadmium red deep to the mix and suggest a few flowerheads in the foreground grasses with light strokes. Use the same mix to pick out warm areas across the painting.

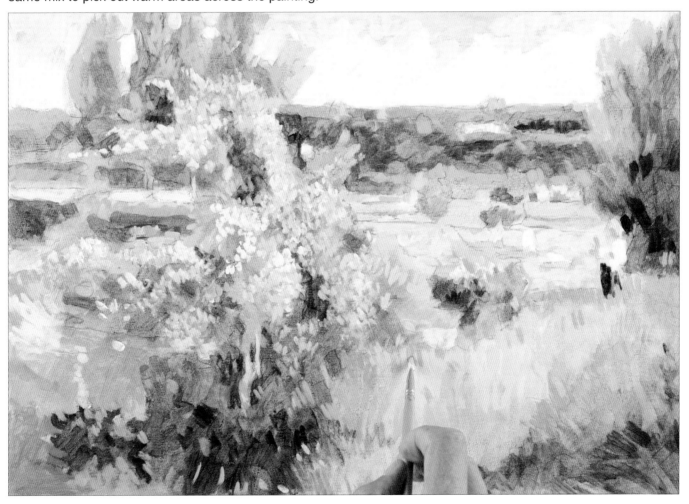

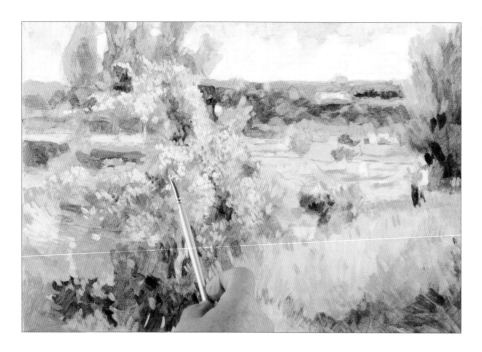

18 Still using the size 2 short flat/bright, add a little dioxazine purple to the mix and detail the figure, before adding touches across the painting. Use very little paint on your brush, and apply it when nearly dry, so that the underpainting is still visible.

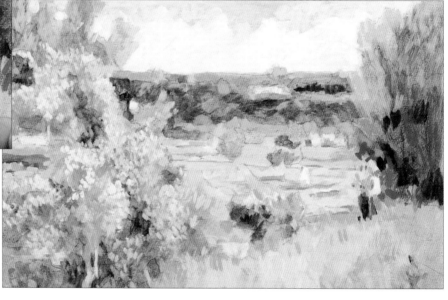

19 Make a dark grey mix of viridian, Hooker's green, ultramarine blue and titanium white, and use the size 1 sable brush to apply some details to the figure (see inset) and the nearby area. Add more titanium white for variation.

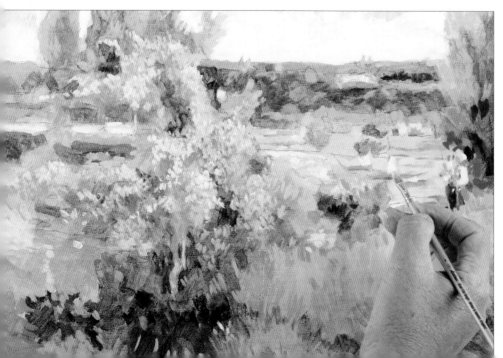

20 Using pure titanium white and the size 2 short flat/bright brush, overpaint the lower part of the sky to bring out the shapes of the trees. Add a few highlights of pure white across the painting in the lightest areas.

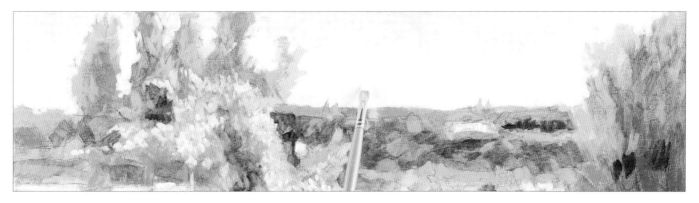

21 Create a mix of titanium white, ultramarine blue and a touch of phthalo blue (green shade). Use this to overpaint the top of the sky.

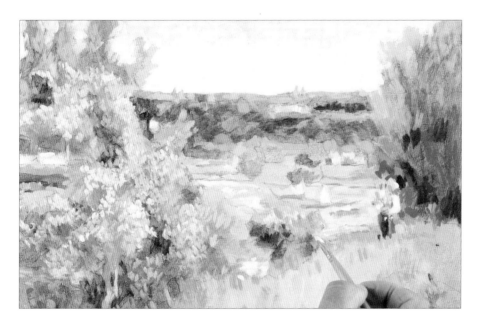

22 Add a little dioxazine purple to the mix and add lilac touches over the blossoming tree, the horizon and the water areas.

23 Still using the size 2 short flat/bright, mix cadmium yellow medium with Hooker's green and a tiny touch of dioxazine purple. Use this mix to add in subtle touches of mid-tone green all across the painting. Use light touches, to allow some of the colours underneath to show through.

Tip

Renoir's paintings are essentially thousands of individual dashes of colour. These later stages, where tiny strokes are made all over the canvas, are important to achieving a similar effect to the Master's work.

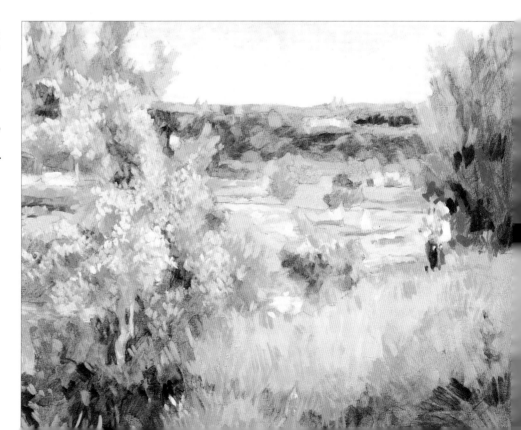

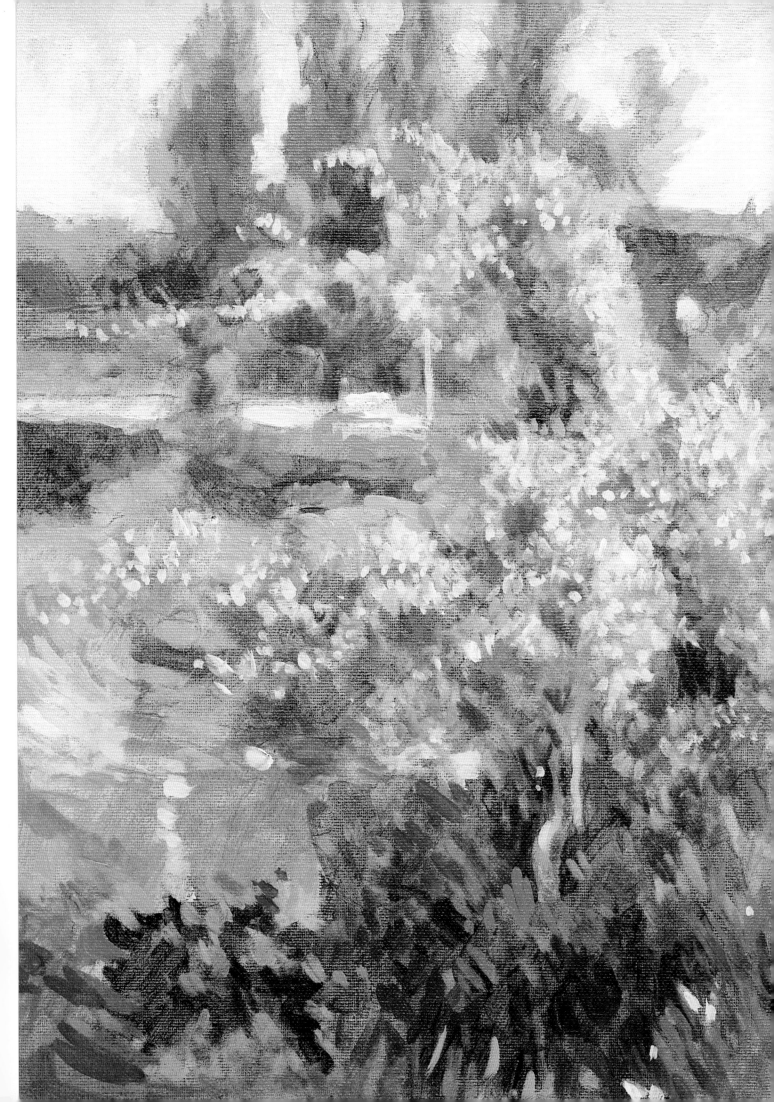

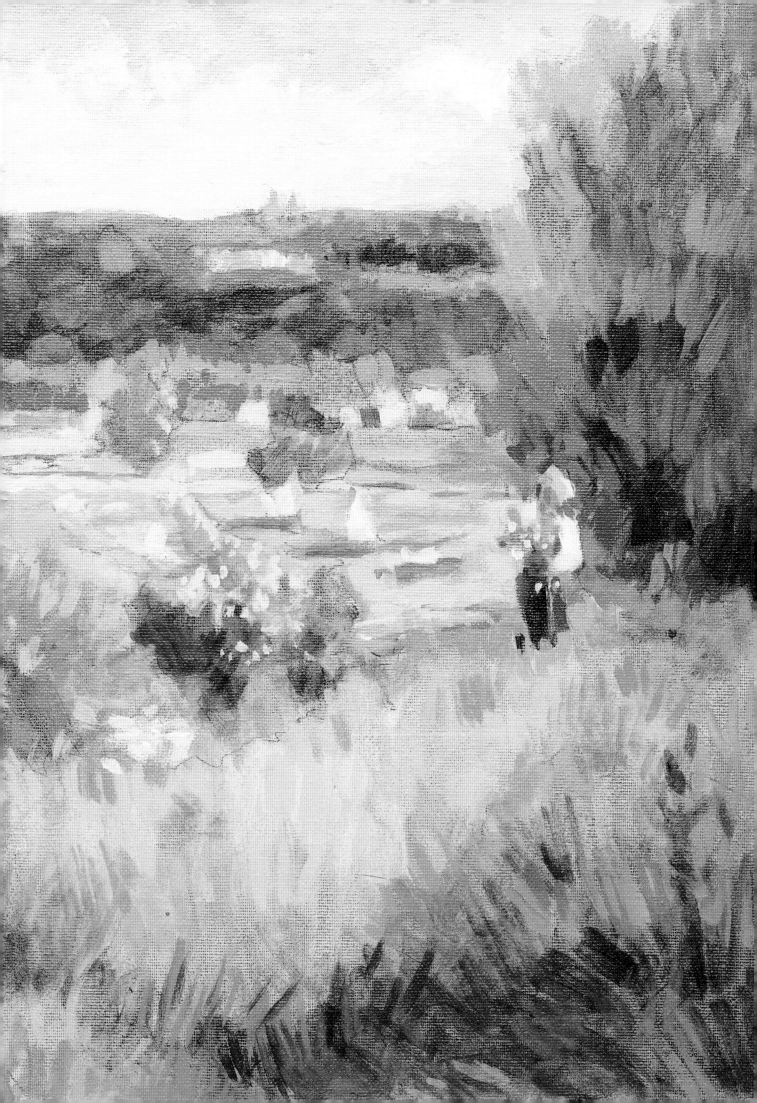

Index

After the Luncheon of the Boating Party
100 x 81cm (39 x 32in)

The original Luncheon Of The Boating Party *is a 173 x 130cm (68 x 51in) canvas painted in 1876 of a happy group of Sunday pleasure boaters on a Seine restaurant balcony. Many of Renoir's friends, and perhaps even a self-portrait, are included in the original. My rendition combines elements from this painting, elements from Renoir's* Dance at Bougival, *and a background of my own favourite restaurant in the Caberra mountains in Almeria, Spain. Try including parts from other paintings by Renoir in a personal picture containing your own ideas and style, and you will have learned much from the great Master of Impressionism, which will help continue the traditions of this school of art into the future.*

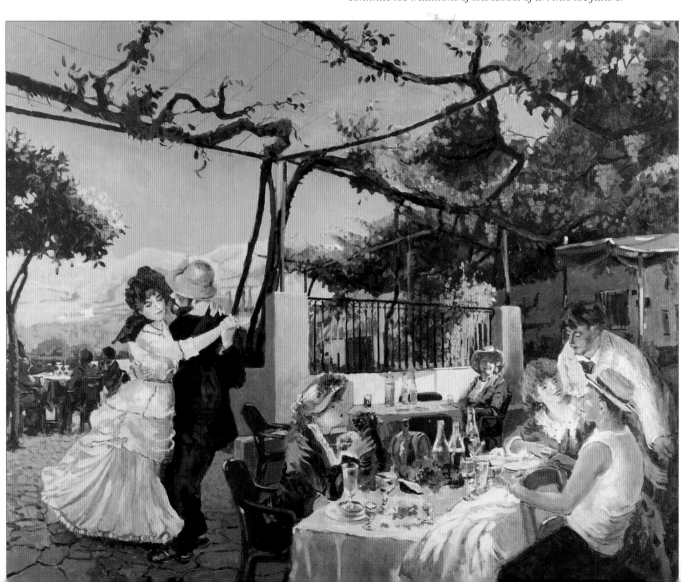